CREATING CHARACTERS

WITH PERSONALITY

CREATING CHARACTERS

WITH PERSONALITY

Watson-Guptill Publications
New York

by **Tom Bancroft**

Introduction by **Glen Keane**

Dedicated to my wife, Jennifer, for all her endless support and love. And to our four silly girls: Alexis, Ansley, Emma and Ellie—you all made it hard to work on this book but without you nothing would be worthwhile.

Special thanks to my best friend and business partner, Rob Corley, who wrote and illustrated chapter seven because he can draw strange, scary creatures way better than I can. Thanks, too, to Paul Conrad, another good friend who colored the cover image as well as the color models and "style" images and provided excellent guidance; the incredible and inspirational Glen Keane, who wrote the Introduction while handling a busy schedule directing a major film; and the awesome contributions from the masters of their trade: Butch Hartman, J. Scott Campbell, THE Jack Davis, Peter de Sève, Bill Amend, and Mark Henn.

Thanks also to my editors at Watson-Guptill, Jacqueline Ching and Stephen Brewer, to the designers of Mada Design, Inc., and to my brother Tony, sister Cami, and my mom and dad, Jim and Cori Crismon.

First published in 2006 by Watson-Guptill Publications,
Crown Publishing Group, a division of Random House Inc., New York
www.crownpublishing.com
www.watsonguptill.com

Senior Acquisitions Editor: Jacqueline Ching
Senior Developmental Editor: Stephen Brewer
Designer: Mada Design
Senior Production Manager: Hector Campbell

Text and illustrations copyright © 2006 Tom Bancroft
Library of Congress Control Number: 2005028462

Library of Congress Cataloging-in-Publication Data

Bancroft, Tom.
 Creating characters with personality / by Tom Bancroft ; introduction by Glen Keane.
 p. cm.
 ISBN-13: 978-0-8230-2349-3
 ISBN 0-8230-2349-4
1. Characters and characteristics in art. 2. Graphic arts—Technique. I. Title.
 NC825.C43B36 2006
 741.6—dc22
 2005028462

Printed in China

6 7 8 9 10 / 14 13 12 11 10

THE MAGIC OF CHARACTER DESIGN

Creating characters has never been easy for me. The designs don't give themselves up without a struggle; there are no formulas for a quick and easy path. To design a character I do hundreds of drawings, exploring and waiting for that moment of recognition when I can see the face of the character I am searching for staring back at me. That is the magic moment I am always working to achieve.

I remember the process of finding the Beast for *Beauty and the Beast*. What would he look like? I had done a myriad of designs and looked at many other artists' versions as well. Any one of the designs could have been an acceptable Beast—but I just knew it wasn't the Beast who "lived and breathed" in our story. My walls were covered with pictures of wild animals of every sort. Lions, bears, tigers, gorillas, mandrills, and wolves. I had one storyboard that was filled with nothing but horns: some that twisted, some that spiraled, short ones, curved ones. I had countless close-ups of eyes, nostrils, and teeth. For months I drew combinations of these elements—strange, hybrid creatures with every permutation of horn, tooth, and facial feature imaginable—but I never achieved that deeply satisfying "Ah-ha!" moment.

Then one day an animator on my team asked me, "So what's the Beast gonna look like?" He stood behind me looking over my shoulder as I sketched, and I explained that I liked the sadness of the buffalo head, the softness of the lion's mane, and the ferocious muzzle of the wild boar. I continued condensing my room full of reference photos into one cohesive drawing …and the Beast suddenly appeared. "That's Him!" It was as if he had always existed, and I was finally able to coax him onto my paper.

This kind of search is personal and intense, so much so that the characters we create seem truly to live and breathe in our imagination. One of the great rewards of our craft is knowing that the close attachment we feel to our characters will be shared by the thousands who will believe in them as well. Designing characters is a magical process, and it's wonderful to have this book in our hands—a book, long overdue, that finally explores our craft in-depth. Enjoy.

Glen Keane
Supervising Animator/Director
Walt Disney Feature Animation

CONTENTS

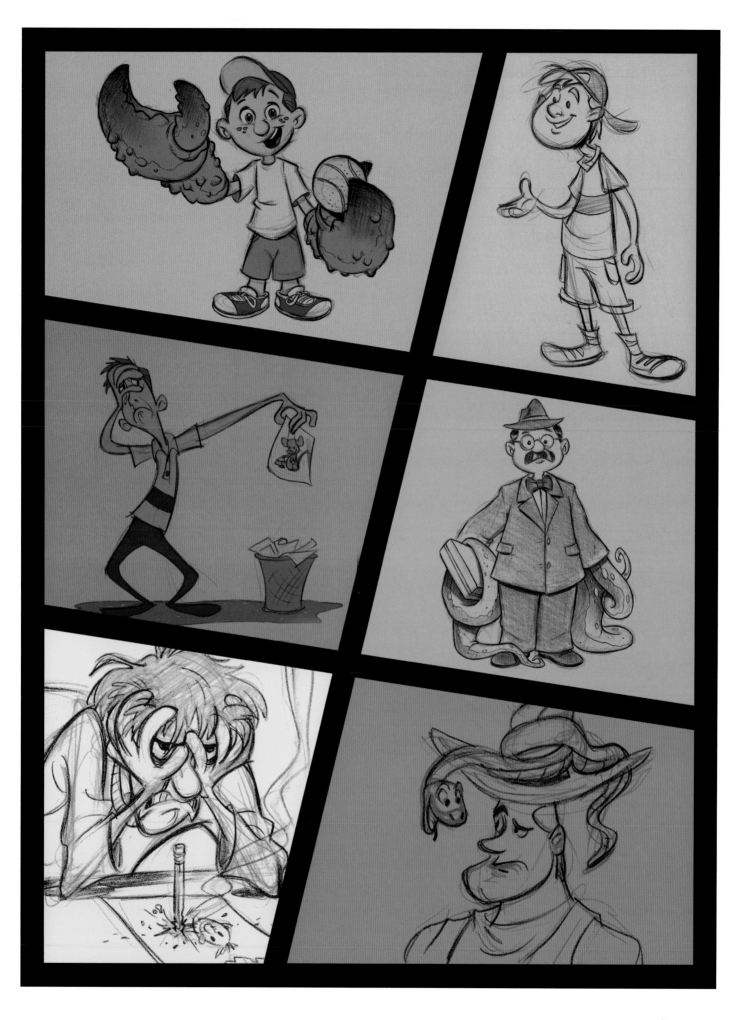

When I was growing up, I bought every how-to art reference book I could get my hands on, taking it on faith that the authors were the best of the best in the fields they were writing about. After all, they wrote the book on the subject, right? Fast-forward to today. Now I am the one writing a book, and I start this book with one disclaimer: I'm not the best writer on the subject of character design. I'm just the guy who wrote this book about creating characters. So take it from me: My notes and suggestions are not hard-and-fast rules; they don't point you to the only way to design characters. They simply represent one artist's views on character design.

Why a book solely devoted to the subject of character design? When asked to design characters for different projects, I usually start by researching the subject in my still-growing art reference library. Long ago I discovered that I didn't own one book on character design, though I had been designing characters for most of my career. That's because there is no such book. There are chapters on character design in most all of the better books on subjects like animation and cartooning and illustration, but to my knowledge, until now, not one book has been entirely devoted to the subject—a surprising omission, given the critical importance of good character design.

Character design is used in every feature film that has imaginary, nonhuman actors in it, and also in some films starring real, live human beings. In fact, character design is one of the first steps on the road to creating the visuals for most all forms of entertainment. The most obvious places where you'll find character designers are the traditional animated television and feature film studios. But in addition, character designers at EFX film studios design creatures for many of the live action films you see today. Character designers work on video games and comic books, and animators of computer-animated films begin with traditional drawings of their characters before modeling them in three dimensions. Character design also appears on the internet, in corporate icons, in illustrations for children's books, and in many other places.

When I sat down to write, I asked myself some key questions:

- Is there more to the subject than would fill a few pages in an animation book? Yes, there definitely is!

- Do more than just a few specific, niche-market artists need to know or would be interested in learning more about character design? You bet!

- Could I bring something to the subject from the point of view of an individual with many years of experience in the feature animation field? Yes, again.

- And what about style? My style is similar to a Disney style, because I spent so many years there. But I enjoy drawing in different styles: Manga style, video game style, comic book style. The point is, don't get too caught up in the style of any given drawing you'll see in these pages. This book is not about style but about the *principles behind the design.* It's about the thought process behind the character design choices you will make, the design aspects that go into a strong design, and, most important, how to infuse your designs with personality. These principles apply to *any* style.

I think I've addressed all these points in this book. I learned a lot in the writing of it, and I hope you'll learn something from it, too. After all, as someone great once said, "The moment you stop learning, you start dying."

Tom Bancroft

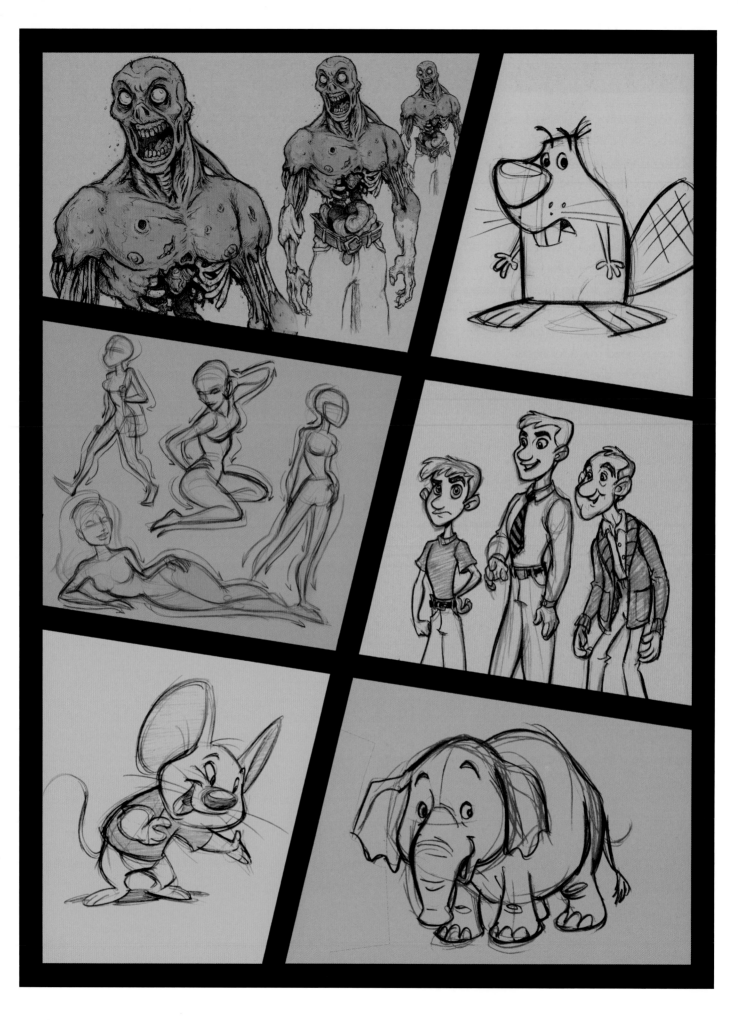

We all have moments in our work as artists that stand out as milestones—moments you will never forget because you learned a principle that finally stuck. You may have heard that same piece of information many, many times before, but in that one special moment of illumination, you *finally got it*. You could feel it, and you would, from that point on, make that principle part of how you approached a drawing. One of these milestone moments occurred for me when I was in my first year at the California Institute of the Arts. It was in our character design class, taught by the very talented art director/designer Mike Giamo. Mike would ask us to show the characters we were designing for our student films. I was in a crowd of other students watching him look at and review each student's characters, one after another. He would ask questions about the character's personality, role in the film, and other details he would need to know to decide if the character could be improved. Oftentimes he would place a fresh piece of paper over a student's drawing and do a quick sketch to illustrate a point. It was exciting to see him easily go over the drawings, making "okay" characters look great!

Then it was my turn. As he had done with the other students, Mike summed up his points with a drawing that he created over mine. I thought I was getting a lot out of watching him design characters and speak about why he was doing the things he was doing with the other students' drawings, but once I saw him go over my own drawing, the light went on! There is something in our creative minds that responds to seeing someone visually tackle the same problems we have struggled with. I believe this is the best way for artists to learn. Read all the books you can get, of course, but I believe the light won't truly go on until you start drawing! That's why I'm going to give you drawing assignments that will illustrate the points I'll be making, and inviting some other pros to share their thoughts, too.

THE ASSIGNMENTS

Throughout this book we will work together on assignments in which we create the characters for an imaginary animated film, a Western. I'll begin with a brief story synopsis and biographies of the characters for this imaginary film on page 22. By the end of the book, we will have a first pass of the main characters in full color.

CREATOR PROFILES

I have also asked some of the most talented leaders in the field of character design to write descriptions of how they would design Dillon, the cowboy hero of our imaginary film. These artists work in comic strips, television animation, feature film animation, comic books, computer animation, and humorous illustration, and they have addressed the design of the Dillon character with their particular styles in mind. Their work here will enable you to see just how wide a variety of choices you'll have when you design a character yourself, and you'll get the added benefit of tips and advice from some of the masters in their field.

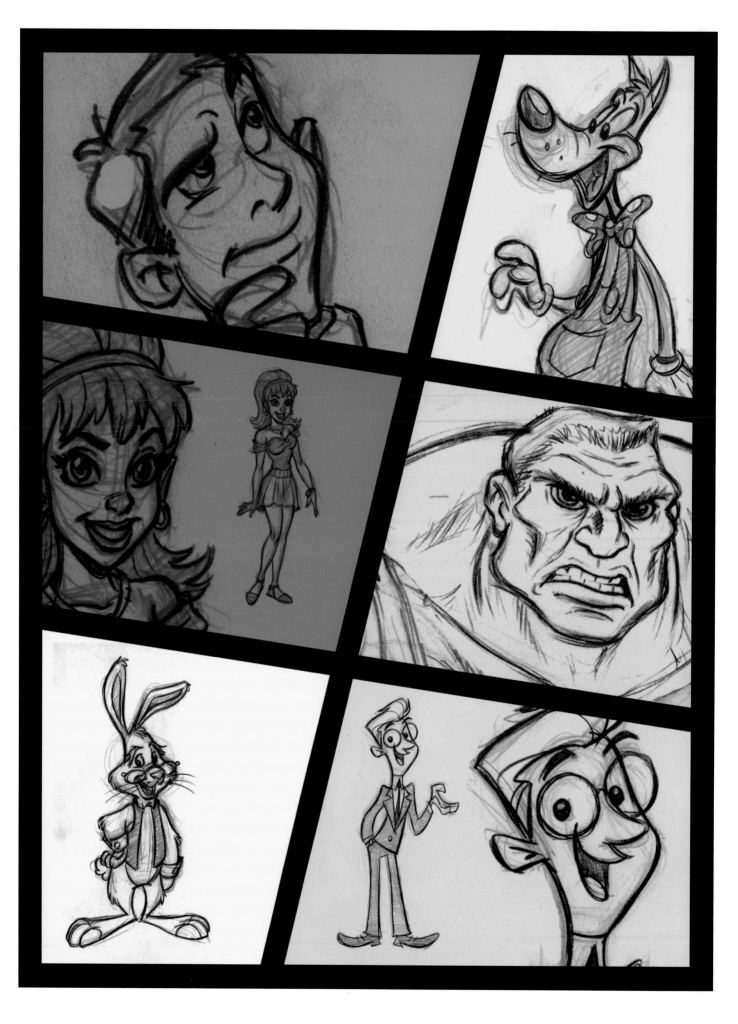

CHAPTER ONE

WHAT DOES A CHARACTER DESIGNER DO ALL DAY?

What is a character designer? Here's the short answer: A character designer is a traditional artist who creates original drawings of characters for the visual media. The character designer's goal is to create characters that fulfill the needs of the script, scene, game, or story and suit the storyline. His or her work might appear in comic strips, television animation, feature film animation, comic books, computer animation, and humorous illustration. A character designer's counterpart in live-action films would be the casting director. In live action, the casting director meets with the director, then auditions actor after actor to find just the right "face" and performance style required for each role. As a matter of fact, an accomplished character designer is also part actor, since a character will seem stiff unless the artist draws the figure in a way that expresses a sense of personality.

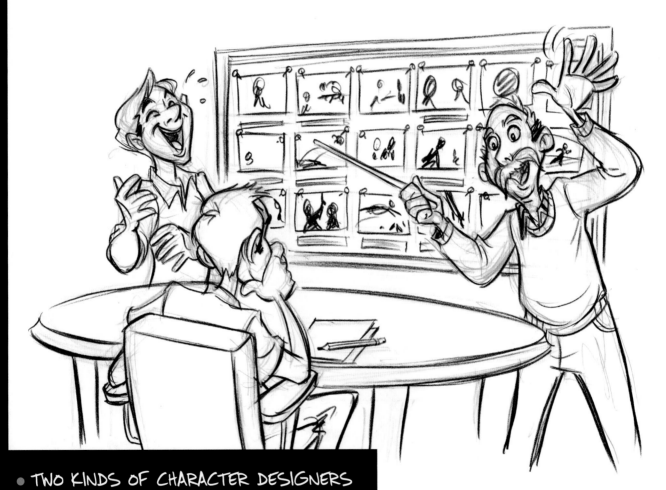

- TWO KINDS OF CHARACTER DESIGNERS
- WHERE TO BEGIN
- IMAGINING THE CHARACTERS
- CHARACTER HIERARCHY

TWO KINDS OF CHARACTER DESIGNERS

As a character designer, you will be asked to design in one of two ways.

BLUE SKY DESIGNERS love a blank piece of paper. They are asked to create many different variations of a character with little guidance as to what the character will ultimately be. So, this job requires as much research as it does drawing. The point is to learn anything that's going to make the character feel real and strengthen his or her personality. I often go through books and go online, looking at costuming, ethnic influences, cultural references, and anatomy. Blue sky designers are in part story people and in part extremely creative, talented artists. They tend to have distinctive styles, have a hard time working in other styles, are not necessarily concerned with consistency, and usually find it difficult to draw a character the same way twice. Blue sky designers are the first people to be called in for major projects, and they produce many, many inspiring designs—many of which, unfortunately, will not be used.

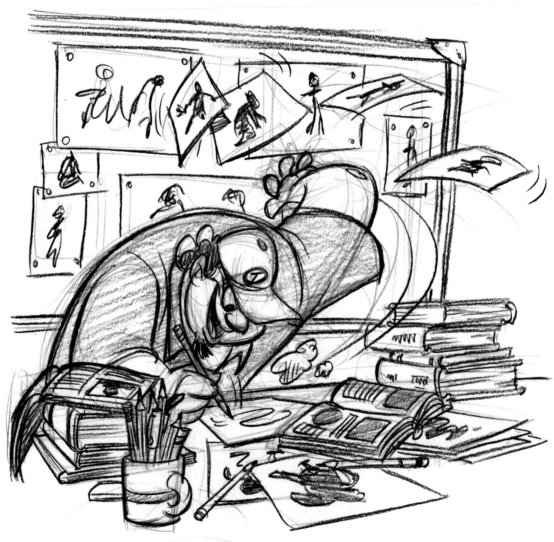

CHARACTER POLISHERS usually work off sketches that blue sky artists have created, or they redefine an existing character. They tend not to have a distinctive style but pride themselves on their ability to replicate other styles while still being able to make a character their own. These artists are great at strengthening an existing drawing, creating consistent orthographic designs of the character, and taking a character and bringing it to life through poses and expressions. More than likely, the director of a project will like parts of three or four drawings that a blue sky designer creates. The director will then ask a polisher to come in and finish the job by putting a cohesive design together. A polisher does so by creating additional expression and posing sheets of the character, also called "model sheets." An expression sheet shows the character from different angles, in different poses and with various expressions. With an expression sheet in hand, a follow-up artist will know what a character looks like from all views and in different moods.

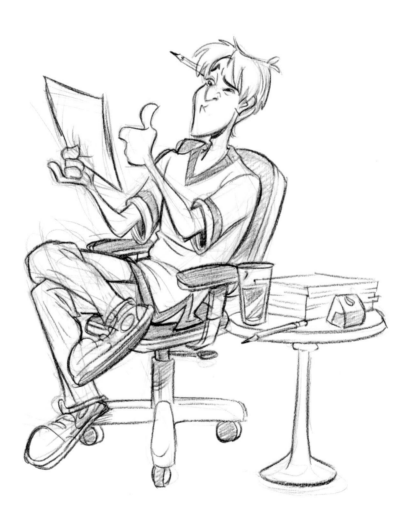

Typically, artists are better at one approach than the other. In these descriptions you will probably recognize which type of artist you are: blue sky artist or polisher. I think that the perfect character designer has elements of both types, though a designer like this tends to be a rare breed.

WHERE TO BEGIN

Imagine you are a character designer who's been hired to work on a feature film for a major animation studio. The directors of the film (there always seem to be at least two, for some reason) have introduced themselves and have pitched the general idea of the film. In a pitch, the directors simply tell the story to you—usually with the aid of plenty of drawings and character designs. After you have laughed, chuckled, and nodded your head appreciatively through their narration of the story, your first step is to go back to your desk and read the script! Then, you're on. Your job is to create the characters for the film.

IMAGINING THE CHARACTERS

Your first task is just to sit and think. Think about the descriptions of your characters, the directors' input, and the reason each character is in the story. Sometimes you'll do your thinking on paper as much as in your head. Once you have the personalities of the characters in your head, you will know the direction to take when you sit down to draw them.

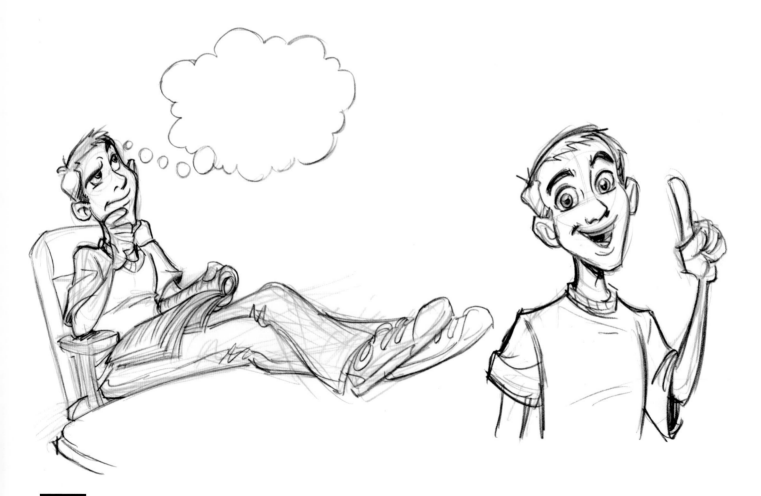

Before you put pencil to paper, here are some questions you should ask yourself:

- What is the character's place in the film? (hero, villain, comic foil or sidekick, heroine, etc.)
- What is the character's personality? (content, dysfunctional, passionate, loving, etc.)
- Are there plot points within the storyline that affect the design? (Dumbo's big ears; Pinocchio's small nose, which becomes long; Shrek's ugliness, etc.)

This information will help you to start formulating your "boundaries." If the hero is a somewhat shy introvert who needs to learn how to come out of his shell to be able to win the day and the girl, you will be wasting your time drawing him as a large-chested, muscular, good-looking guy, right? This is one boundary. I don't want to say that you shouldn't think beyond the boundaries, just that sometimes it's good to establish what you *don't* want to do! The character's description in the script will even help you to know what shapes you should start with in your design. Maybe your hero will be heavyset when you start creating him. If that's the case, you'll be emphasizing round lines and contours, as well as short legs and a small or nonexistent neck, which will accentuate the large shape of the torso.

OR

IDEAS DON'T COME OUT OF THIN AIR

Go to movies, look at magazines, spend time on the Net. Using these resources, you'll find a wealth of images of all kinds of people and clothing. You'll be inspired to make your characters as fresh and original as possible.

CHARACTER HIERARCHY

Another thing you will want to establish with the directors before you start drawing is the hierarchy of the cast of characters. In the world of character design, character hierarchy refers to the different levels of simplicity, or realism, you create for your individual characters, based largely upon each character's role and function in the story. Here are six main categories of character design.

Iconic
Extremely simple, almost graphic. Very stylized but not very expressive. Usually the eyes are orbs, without pupils of any kind. (Early Mickey Mouse and Hello Kitty are examples.)

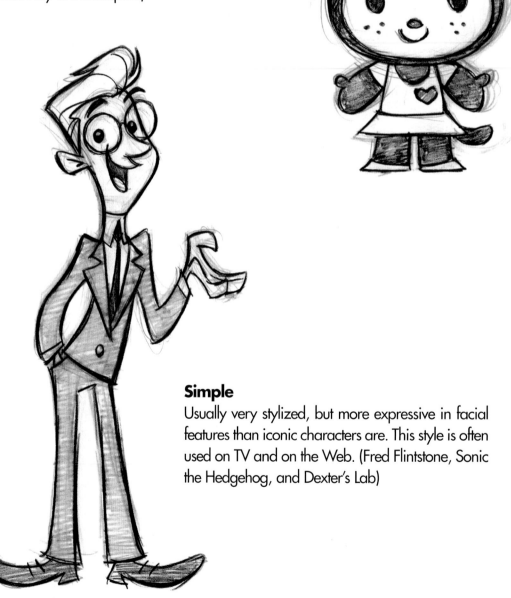

Simple
Usually very stylized, but more expressive in facial features than iconic characters are. This style is often used on TV and on the Web. (Fred Flintstone, Sonic the Hedgehog, and Dexter's Lab)

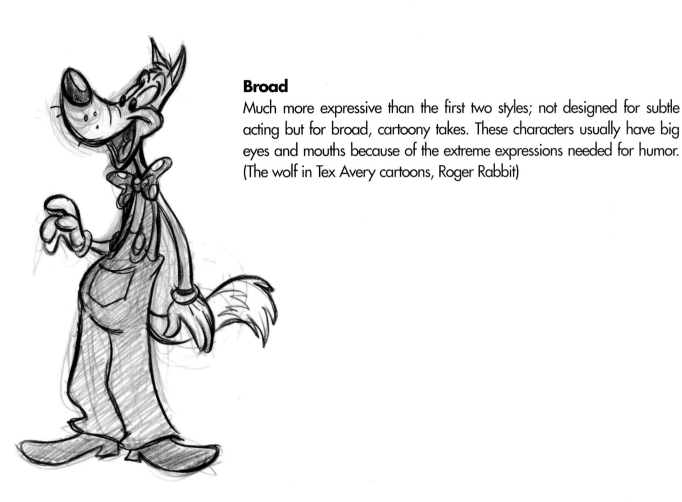

Broad

Much more expressive than the first two styles; not designed for subtle acting but for broad, cartoony takes. These characters usually have big eyes and mouths because of the extreme expressions needed for humor. (The wolf in Tex Avery cartoons, Roger Rabbit)

Comedy relief

Does not convey the broad visual humor of the above characters but can achieve their humor through acting and dialogue. The facial anatomy is less broad as well. Most Disney sidekicks are at this level of design. They need to crack jokes, but will also usually need to be subtle in their acting at some point in the film. (Nemo, Mushu, and Kronk)

Lead character

Very realistic in facial expressions, acting, and anatomy. The audience needs to connect with these characters, so they must be able to emote like we do. To do this, they need to have more realistic proportions and expressive faces. (Sleeping Beauty, Cinderella, Moses from *Prince of Eygpt*)

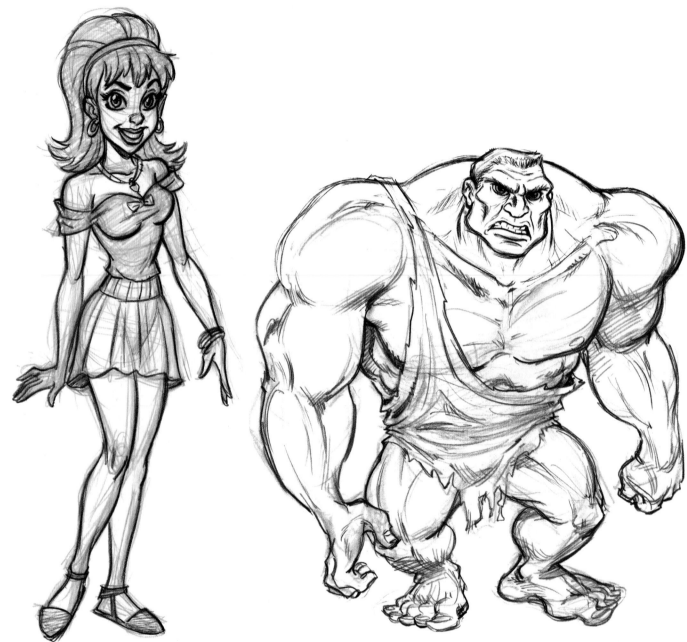

Realistic

The highest level on the realism scale, just short of photorealism but still with some caricature in the design. Strong-effects film monsters, comic-book characters, and some computer-graphics animated film characters fall in this realm. (The Princess in *Shrek*, most comic-book characters)

In most films you will have between two and four of these six levels. Let's use *Shrek* as an example: Though this is a very realistic film, I would say Donkey is on the Comedy Relief level, Shrek is in the Lead Character level, and the Princess is fully on the Lead Character level. Meanwhile, the Gingerbread Man character is on the Iconic level. In a film dominated by more realistically drawn characters, Gingerbread Man introduces some variety and sticks out because of his flat, simple design.

Usually, a character on one end of the hierarchy spectrum (Iconic or Simple) doesn't look right next to one on the other end of the spectrum (e.g., Lead Character), as in Figure A. A good example of this is *Snow White and the Seven Dwarfs*. The film is a classic, but let's face it, the dwarfs look odd next to Snow White. Now you know why. Figure B is an example containing figures much closer together on the character-hierarchy ladder. I think this works better.

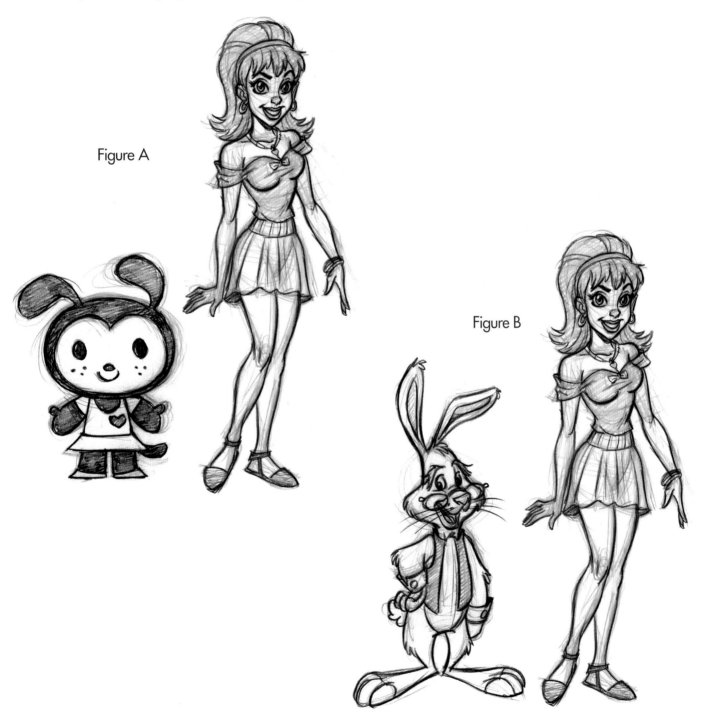

Figure A

Figure B

Assignment one

As I discuss on page 11, throughout this book we're going to work on assignments in which we create an imaginary film. Here's a synopsis and character bios. Read this info and start thinking about how these charactesr will fit into the film and how, based on these descriptions, you might illustrate them.

Film Synopsis

It's 1815, and a small Old West town called Smithville has a secret: According to an age-old legend, hundreds of years ago thieves raided the Mayan treasures of Mexico and barely escaped with their lives. The thieves created a labyrinth of tunnels in the isolated spot where Smithville now stands. What they did not realize is that they had been cursed, and soon they all perished.

The thieves left a hidden map leading to the location of the riches. Now, years later, Smithville is almost a ghost town and is on the verge of disappearing. The ancient legend has long been forgotten or ignored, except by Dillon, son of the local panhandler. Dillon believes the ancient stories and has decided to find the treasure in order to save the little town he loves.

Dillon is lazy, but he has a pure heart and an incredible natural gift for gun-slinging, though he doesn't use his gift much, since it tires him out. The only thing that really gets Dillon's heart racing is Polly, the beautiful, red-haired daughter of the town's beautician.

Unfortunately, Polly is betrothed to the town's sheriff, Brent Baxley, a dashing English gentleman whose heart is black and whose intentions are cruel. Polly has no knowledge of this side of Brent. In the end it becomes a race between Dillon and Brent to find the lost Mayan treasure. They compete for the heart of Polly and to save the town as they explore the maze of tunnels studded with booby traps.

Cast of characters

Dillon The lazy, but brave, hero. He is tall and thin, with blond hair and dirty, ragged cowboy clothes. His clothes and hat all should look a mite too big for him, since they are hand-me-downs from his out-of-luck father. He has a natural ability to be a gunslinger, but he never practices. Few people know that he could be the best there ever was, if he had any motivation in him. Even with his lack of gumption, Dillon is very likable, as he has a heart of gold, cares for the town and all the people in it, and treats his best friend, his horse, like a brother. If he could ever muster some motivation, he could win Polly's heart and become mayor of the town he loves.

Polly A beautiful, red-haired country girl. She is part tomboy, part lady, but all firecracker! She has all the motivation that Dillon lacks. She just can't see herself with someone without a goal in life. She enjoys the company and exotic British ways of the town sheriff, but she has a strange feeling in her soul that something about him isn't right. Her mother is owner of the always empty beauty parlor in town.

Brent The sheriff gone wrong. He is a dark-haired dapper dresser from England. Why he came to this small town is a mystery to all, though he claims it is for the beautiful nearby hills and how they help his disposition. He maintains a pleasant demeanor, but when people aren't around, he enjoys being cruel to animals, especially to Polly's little dog, who hates him.

Ruthie Polly's loyal but grumpy Shiatzu dog. She senses Brent's true motives and bites him often. She likes Dillon, so much so that she is jealous of Polly whenever she and Dillon are together. A strange love triangle ensues, but it is only in Ruthie's head.

Carrots Dillon's horse, named after his addiction: carrots. He eats so many of them that he has an orange tint to his coat, which makes him stand out in the horse crowd. Thanks to his carrot habit, he also has incredible vision. He is a lean stallion, but, like his master, is not very motivated. Dillon and Carrots are lifelong best friends, though they don't always agree.

Grit The very muscular—and muscle-headed—deputy of the sheriff. Just as cruel as Brent but far less coy about it. A very intimidating guy.

A few townspeople These include Polly's beautician mom, Dillon's hobo dad, a bartender, a cook, and a washed-up cabaret chanteuse who now does Old West-style dinner theater.

Throughout this book we'll be working together to create the cast of an animated film, a Western. I have also asked leaders from various fields of character design to provide a design for Dillon, the cowboy hero of our imaginary film.

Butch Hartman, creator and executive producer of *The Fairly Oddparents* and *Danny Phantom*

Michigan native Butch Hartman remembers wanting to create cartoons as far back as kindergarten. "I drew a picture of my teacher and she kept raving about it. I realized art was a good way to get attention and I was hooked," he says.

Hartman pursued drawing through high school then attended California Institute of the Arts to study animation. He went on to work for many of the top animation studios, including Don Bluth, Marvel Productions, Hanna Barbera, Amblin Television, and Nickelodeon. While at Nickelodeon, he created, wrote, directed, and was executive producer of the award-winning series *The Fairly Oddparents* and more recently the acclaimed series *Danny Phantom*. Butch Hartman lives in Los Angeles with his wife and two daughters.

HIS THOUGHTS ON DILLON

Designing characters has always been my first love. Starting with a blank page and coming up with something from nothing is a blast. The challenging thing is making the character appear to have "life" and a thought process, even though it's nothing more than a pencil sketch. In the design of Dillon I decided that I had to come up with a guy the audience would really respond to. I had to get the audience to like him, as they would any good hero. That's what character design is all about. Not just making interesting drawings, but creating great characters.

In the character design of Dillon, the cowboy part was easy. I drew his hair long and unkempt because that's the way I figured cowboys probably wore their hair. Not much of a chance to get to the barbershop. He's also a good guy who doesn't really want to hurt anybody, so I gave him a pop gun. Something funny. The exposed stomach gives the sense that he's probably too lazy to get a shirt that fits him or is simply too lazy to pull it down all the way. The "too big" hat adds to the unkempt feeling. The small feet help to offset the giant hat and also give that "stylized" feeling that I love in a good design.

Butch Hartman

creator and executive producer of The Fairly Oddparents
and Danny Phantom

 Getting Dillon's personality to come across took a bit more work. I know he's lazy and goofy, but he still has to look like the hero of the story. The goofy smile and big eyes really make for an inviting expression that helps to draw you into the character. And that's the main thing. Let's *like* this guy! Let's see more of him! That's the objective: A great character that the audience will root for time and time again. Hopefully, I was successful.

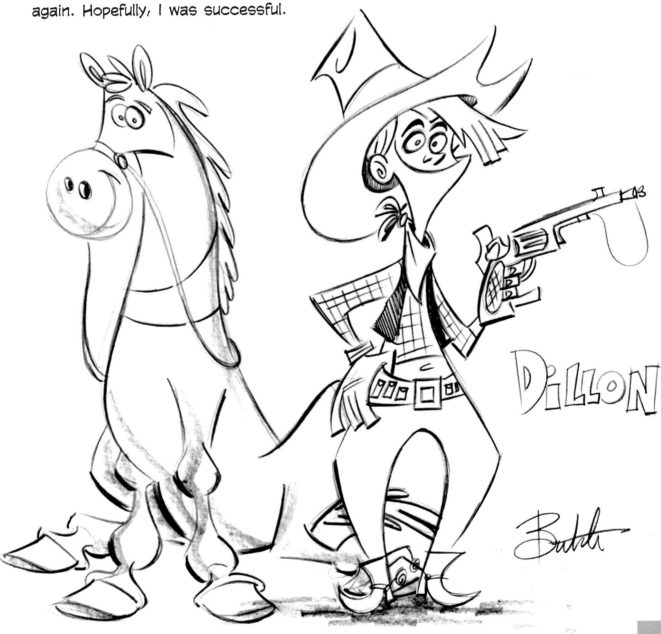

DILLON

CHAPTER TWO

LET'S START DESIGNING CHARACTERS!

As soon as someone says cartooning, does the fine artist in you shut off? It shouldn't, but have you ever seen talented, realistic-style illustrators draw cartoon characters? Often, the result is a blobby, undefined, expressionless figure. Why? Because these artists slough off and don't apply all of the design and illustration concepts they would use in a realistic, rendered illustration. What many artists don't realize is that good cartoon illustration requires as much talent as realistic painting. As you'll see, though, the secret to creating a good cartoon is knowing when to stop "working" a drawing, and sometimes that can be harder to do than to continue adding details.

- THE MEAT, POTATOES, AND VEGGIES OF CHARACTER DESIGN
- SHAPE • SIZE • VARIANCE
- BEGIN WITH THE BASIC SHAPES • DOGGY DO!

THE MEAT, POTATOES, AND VEGGIES OF CHARACTER DESIGN

Before we jump into designing our first character, let's go over some visual design basics that we will apply to our character designs. Shape, Size, and Variance are the basic elements of character design, what I like to call the "meat, potatoes, and veggies." They are the foundation of your design in its most basic form. Remember, though, that these are just a few of many design rules or concepts that will help you create a stronger character design. The more you learn, the stronger your drawings will be.

SHAPE

This is the meat. Is the head a circle or a square? The overall shape will speak for the character's personality even before he or she utters a word. Also, knowing how to break your character into basic shapes is key to recreating that same design from different angles and poses.

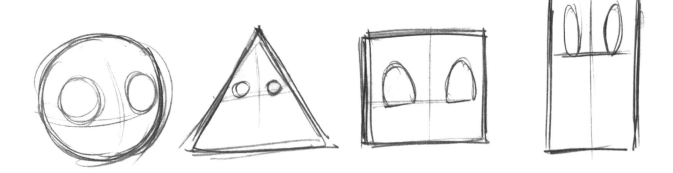

Simple shapes make simple characters . . .

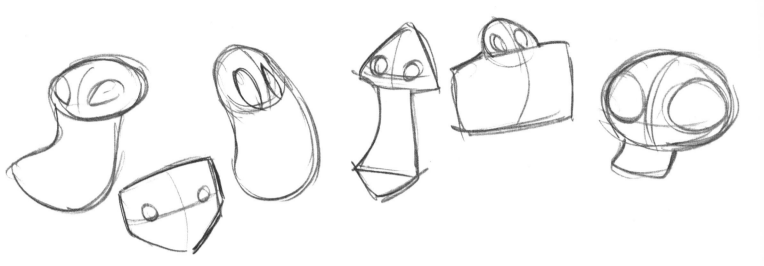

. . . while combining shapes makes more complex characters. Some slightly more complex characters will be made up of altered shapes; that is, a shape composed from multiple shapes. Being able to recognize a shape's origin will help you re-create the character. The example below begins with (1) a basic oval shape as its base, but (2) slices off the front third at an angle to create a flat surface. Next, (3) a square shape with a flattened triangle on the bottom is added. Then, (4) the smaller, interior shapes are added and, finally, (5) the lines are rounded and varied as the details are added. Voila!

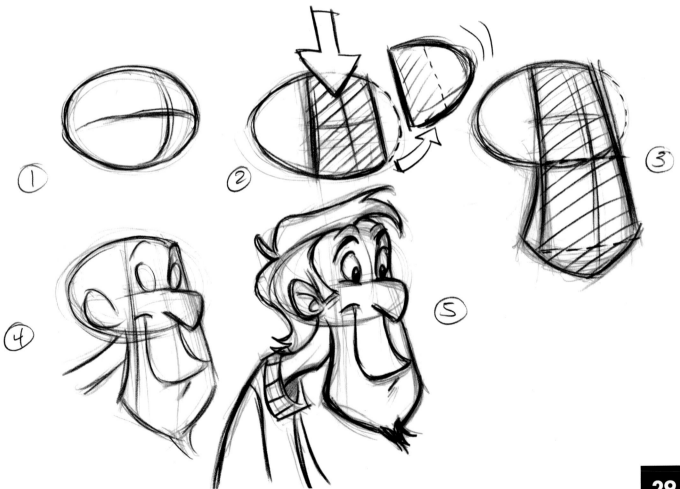

Here is a wide variety of different characters. All are comprised only of basic shapes or variations of them. Even with no facial details, expressions, clothing, or posing, you can start to see some personality coming through. This is why the "almighty shape" is the first thing you need to think of when starting your character design. Remember, too, that each of these designs can be rearranged into an endless number of different character designs.

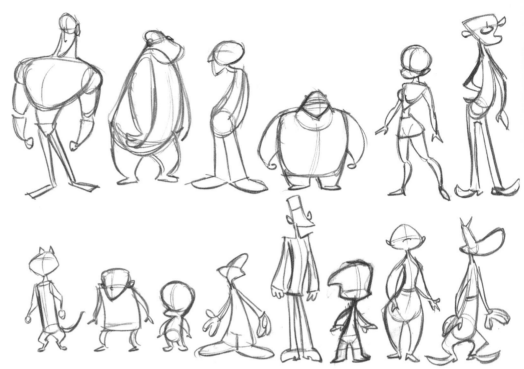

You should be able to break down any character into simple shapes. If you can figure out what the shapes are, then you can draw any character from any angle, even if you haven't drawn the character from that angle before! This, by the way, is the basic idea behind any animation drawing. Because of the great number of drawings involved in animation, an animator needs to be able to sketch out even the most complex characters quickly. The animator then checks to see if a particular movement the animated character will be making works. If everything looks good, then the animator adds the details. This philosophy should apply to all forms of character drawing. An artist should be able to use basic shapes to sketch quickly, evaluate the outcome, and be willing to abandon a drawing that is not working before committing too much time to details and rendering.

Now that I know the shapes that make up this hero's head, I can show him from any angle I can think of with relative ease. I don't get tied down with details at this point.

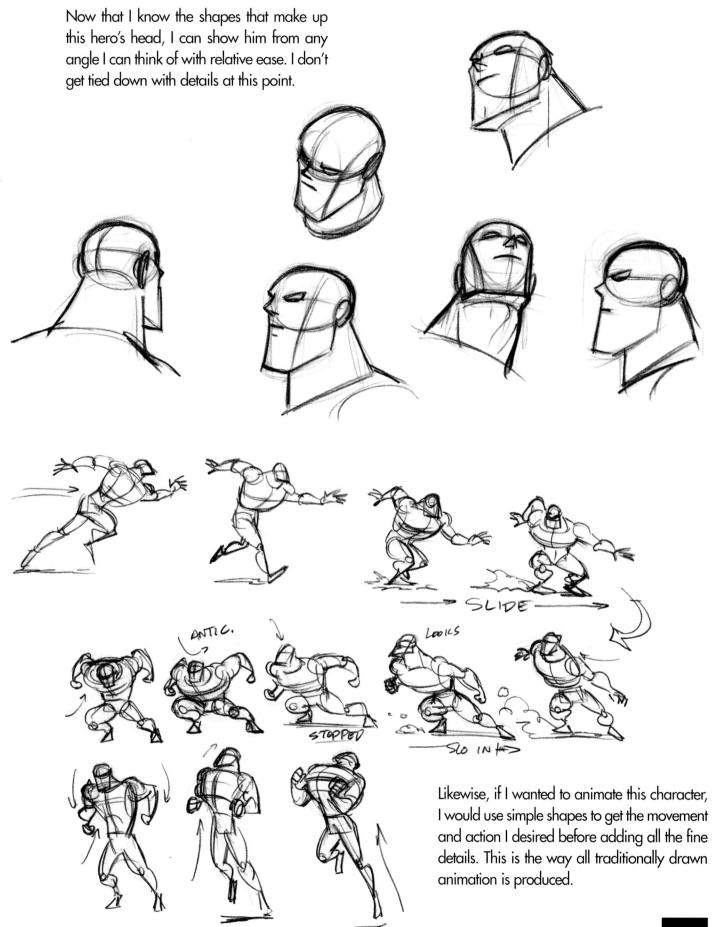

SLIDE

ANTIC.

STOPPED

LOOKS

SLO IN

Likewise, if I wanted to animate this character, I would use simple shapes to get the movement and action I desired before adding all the fine details. This is the way all traditionally drawn animation is produced.

SHAPE SYMBOLISM

When you begin to think about your characters, it's always good to ask yourself questions like: How old are they? When did they live, or where do they live now? Are they rich or poor? Genius or dope? Hero or comic relief?

Remember, base your questions about the character you're designing on any descriptions you may find in the script or in a client's requests. Once you've come to some decisions on the direction you need to go with your design, the next step is understanding the power of the almighty shape! Circles, triangles, and squares! Oh my!

These basic shapes will give you the visual cues you need to describe your characters. They become the foundation for your characters' personality traits and overall attitudes. With that said, let's take a look at some ideas about how shapes are used to provide visual cues in character design.

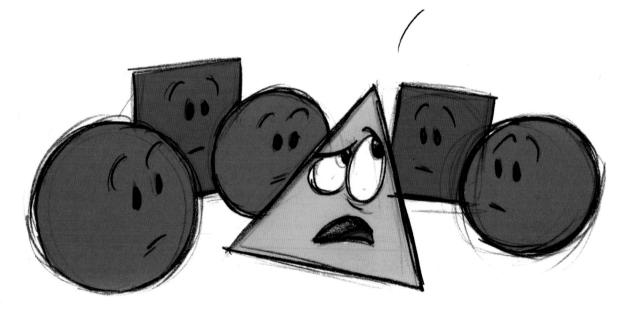

I MEAN SOMETHING.....I JUST CAN'T REMEMBER WHAT IT IS..........

CIRCLES evoke appealing, good characters and are typically used to connote cute, cuddly, friendly types. Consider Santa Claus, or endearing, fuzzy animals. Attractive women are often described with a lot of curves and circles, and drawings of babies usually rely heavily on circular shapes as their visual cues.

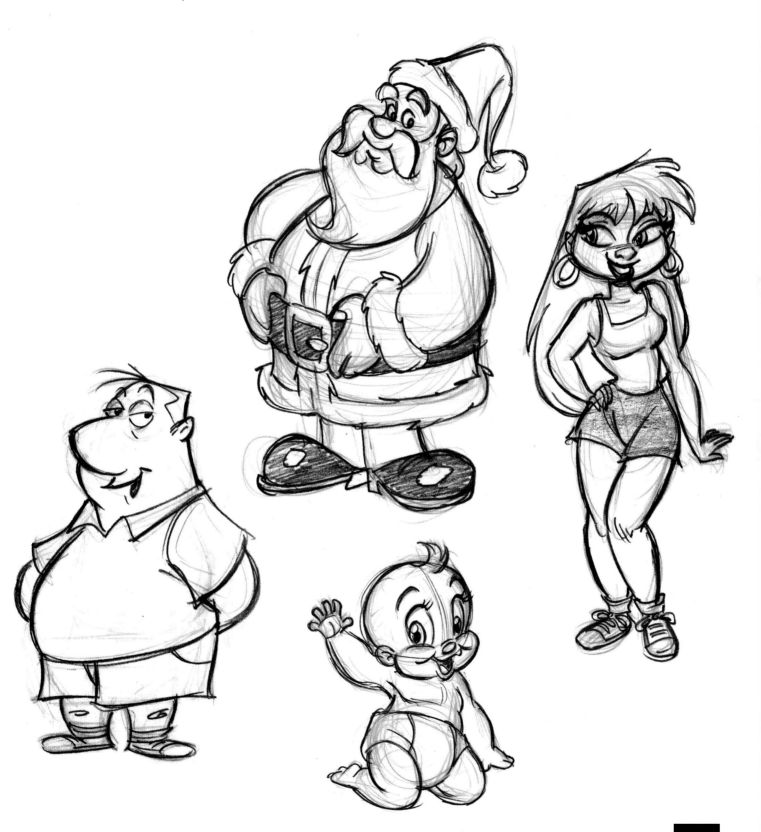

SQUARES usually depict characters who are dependable or solid, or play the heavy. Next time you're out at a club, check out the bouncer, one big old square. The design of superheroes often relies on square shapes.

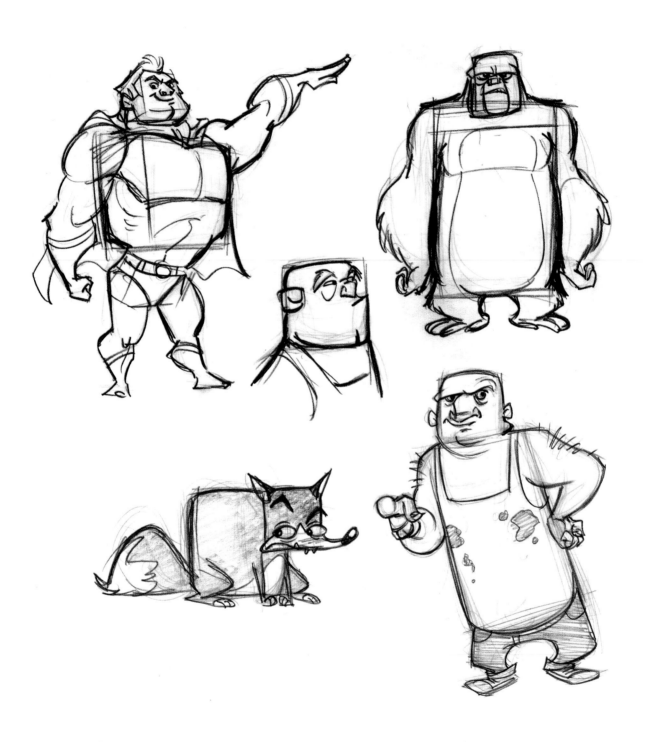

TRIANGLES easily lend themselves to more sinister, suspicious types and usually represent the bad guy or villain in character designs. Consider Darth Vader: His whole head is one big, mean triangle!

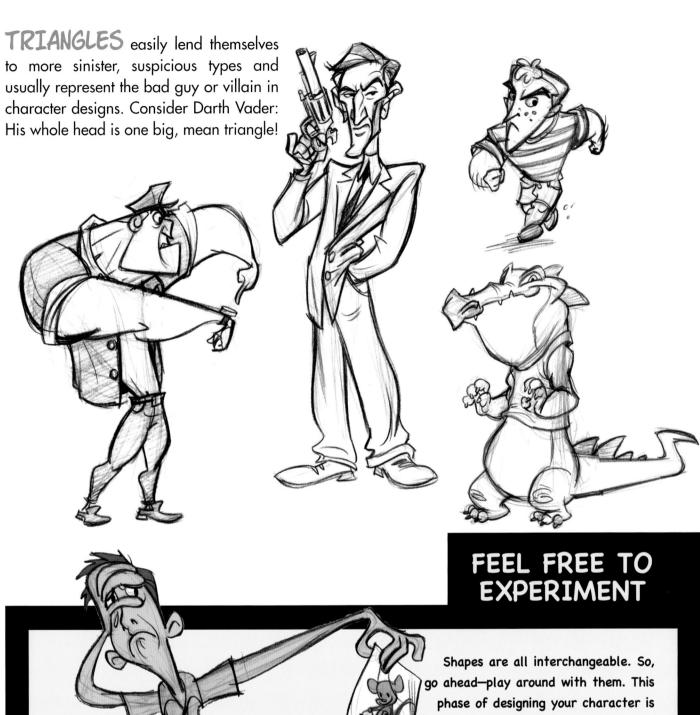

FEEL FREE TO EXPERIMENT

Shapes are all interchangeable. So, go ahead—play around with them. This phase of designing your character is about testing the waters and strengthening the design. What works? What doesn't work? Which combination of shapes best describes your character and fulfills the criteria of the story? One of the best things I learned early on in my career was not to fall in love with my drawings. If you can throw away a decent drawing because it doesn't work for the purposes of the story, then you will be free to produce excellent drawings that do work!

SIZE

Interesting size relationships between shapes make for a stronger design with more visual interest.

Think of small, medium, and large shapes. In fact, think of an ordinary snowman. Traditionally, a snowman is created by stacking large, medium, and small circles like this:

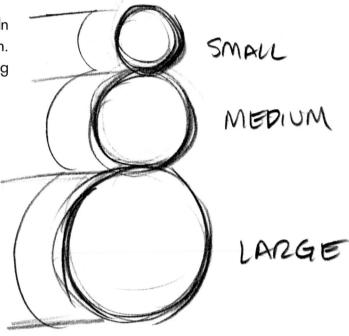

SMALL

MEDIUM

LARGE

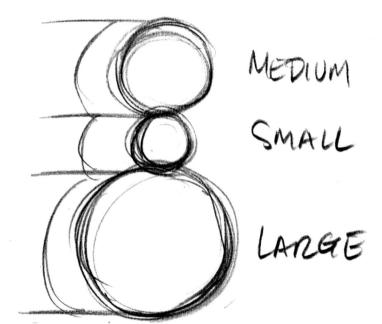

MEDIUM

SMALL

LARGE

The arrangement above is dull and predictable. By varying the size of these same shapes, we can create a look that is more interesting. While this stacking wouldn't work too well for an actual snowman, it does make for a stronger design, because the size relationships are more dynamic.

The size-relationship principle illustrated by the snowman applies to many different parts of a character's design. Look at these two drawings. The design on the left uses fairly bland and even-sized relationships; the one on the right has been pushed to maximize the shape-size relationships. This makes for a more dynamic character design.

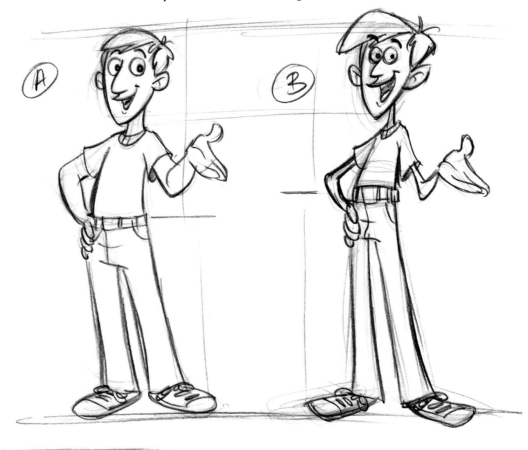

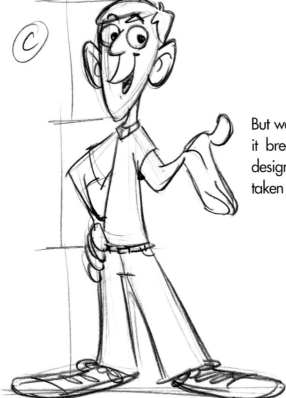

But watch out! A design can be pushed so far that it breaks! Here's a drawing that uses the same design, but the size relationships in it have been taken too far. It's just plain odd at this point.

Even tufts of hair can gain from the "small, medium, large" rule of size relationships. At Disney, we were very careful to draw hair with as much variety in size and shape as possible, because this variety strengthens a drawing considerably. It's worth noting that you can create different textures with your fluffs and tufts by drawing them either more angular or more round. The rounded hair tuffs will evoke the look and texture of softer hair, while angular hair will feel more coarse.

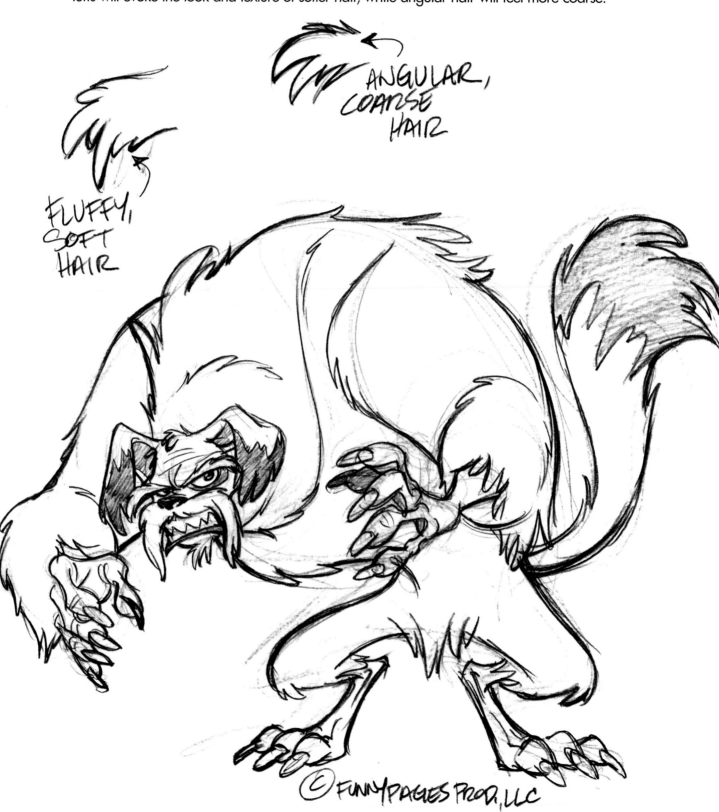

ANGULAR, COARSE HAIR

FLUFFY, SOFT HAIR

© FUNNYPAGES PROD, LLC

Look over the basic descriptions of the main characters for our imaginary film (see page 23). Think about the cast as basic shapes. Using the principles of shape symbolism, what basic shapes will help show off their purpose and personalities in the film? Do they have individual shapes that delineate their characters? Create a basic shape lineup of the characters based on these descriptions; the one here is just a suggestion. Think about the characteristics of each character that led you to choose the shapes you did. Remember, we're just beginning—you can change or refine these shapes later.

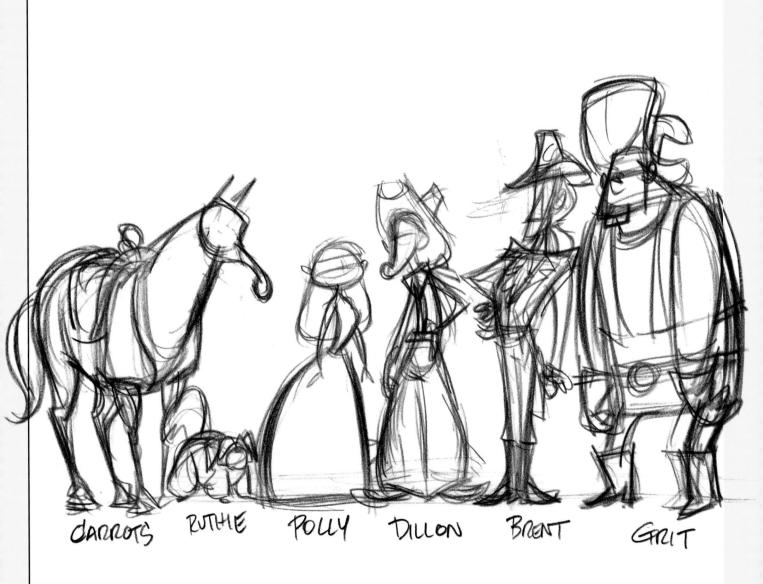

CARROTS RUTHIE POLLY DILLON BRENT GRIT

VARIANCE

Variance refers to the spacing and variety of sizes and shapes in your design. Creating more variety in your design will give it vitality and a push that will turn a good design into a great one! Here are a few design principles that will help you use variance to your advantage (and to the advantage of your characters).

CONTRAST IN LINE can apply to differences in the thickness of lines as well as

differences in their length. In both cases, contrast of thickness and length in the lines you draw lends visual tension and visual interest to your design. Likewise, placing the lines at angles to one another creates tension and is another way to introduce contrast.

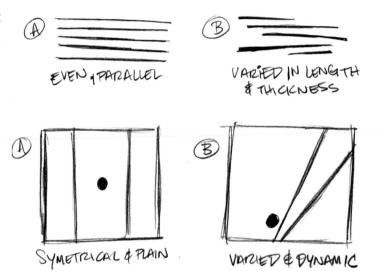

STRAIGHT LINES JUXAPOSED AGAINST CURVES

can make a design more lively and interesting. By putting a curved line opposite a straight line you introduce dynamism and avoid parallel lines, which create a static look. Using this principle will also lend a natural crispness to your design, so you won't get the mushy shapes that result when curved lines come out of other curved lines.

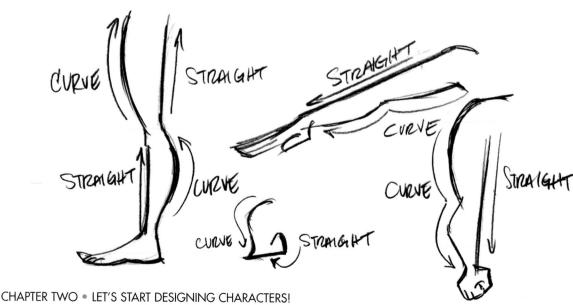

RECURRING SHAPES WITHIN THE DESIGN can help create a theme. The different sizes of the recurring shapes add variety, as does the presence of other, different shapes among those that recur.

NOTICE THESE REOCCURRING SHAPES:

NEGATIVE SPACE, the spaces or gaps between the shapes you are creating, will help to define your character visually. Also, the variety of negative shapes and their interplay with one another, as well as with the positive shapes, makes for stronger, more interesting silhouettes.

X = NEGATIVE SPACE

BEGIN WITH THE BASIC SHAPES

Now, let's road test shape, size, and variance, and look at how you can combine all three elements in the same design for maximum effect.

Let's start with three identical circles.

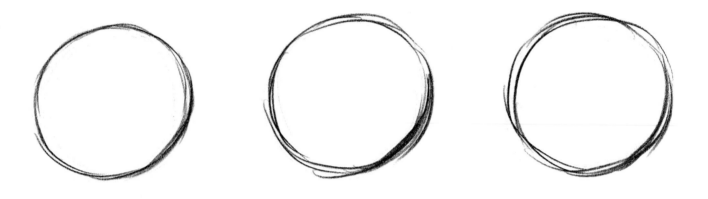

These are the basic shapes to work when constructing a character's face.

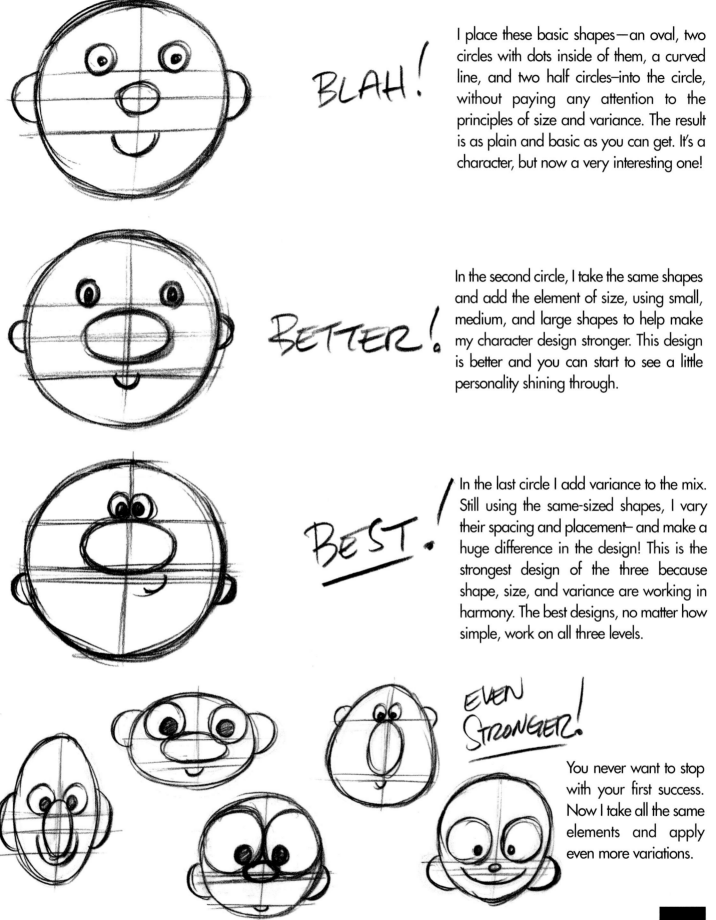

BLAH!

I place these basic shapes—an oval, two circles with dots inside of them, a curved line, and two half circles—into the circle, without paying any attention to the principles of size and variance. The result is as plain and basic as you can get. It's a character, but now a very interesting one!

BETTER!

In the second circle, I take the same shapes and add the element of size, using small, medium, and large shapes to help make my character design stronger. This design is better and you can start to see a little personality shining through.

BEST!

In the last circle I add variance to the mix. Still using the same-sized shapes, I vary their spacing and placement— and make a huge difference in the design! This is the strongest design of the three because shape, size, and variance are working in harmony. The best designs, no matter how simple, work on all three levels.

EVEN STRONGER!

You never want to stop with your first success. Now I take all the same elements and apply even more variations.

DOGGY DO!

Let's apply shape, size, and variance to more complex characters. We'll start with a cartoon dog. No specific breed, just a mutt of some kind. Think about all the different kinds of bodies, ears, eyes, and noses you might find on a dog. Getting an idea of the design elements you want to use is the first step in designing a character.

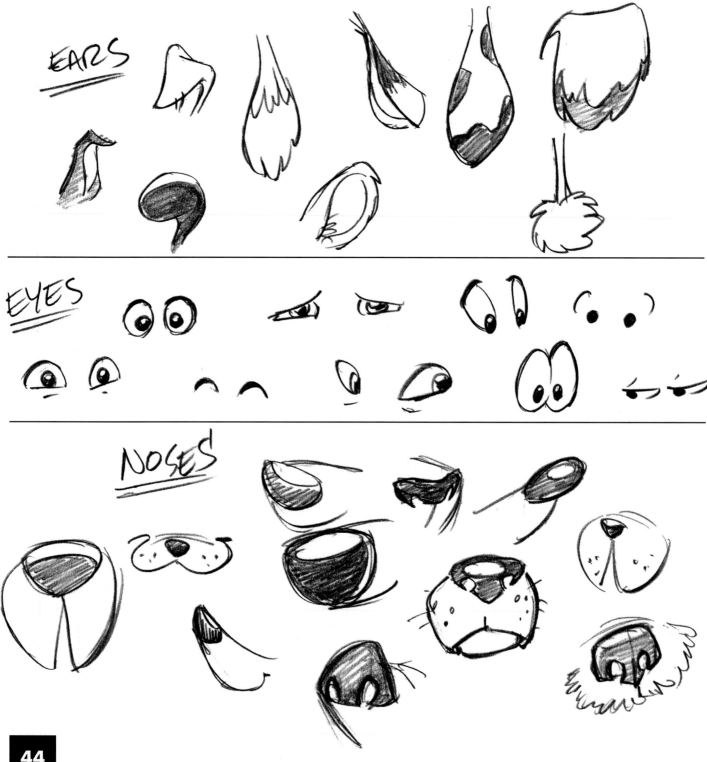

EARS

EYES

NOSES

Now we can jump in and generate a bunch of different dog designs. The idea here is to try to make each one as different as possible. Try different noses, ears, and eyes. Have fun! Here's my first batch:

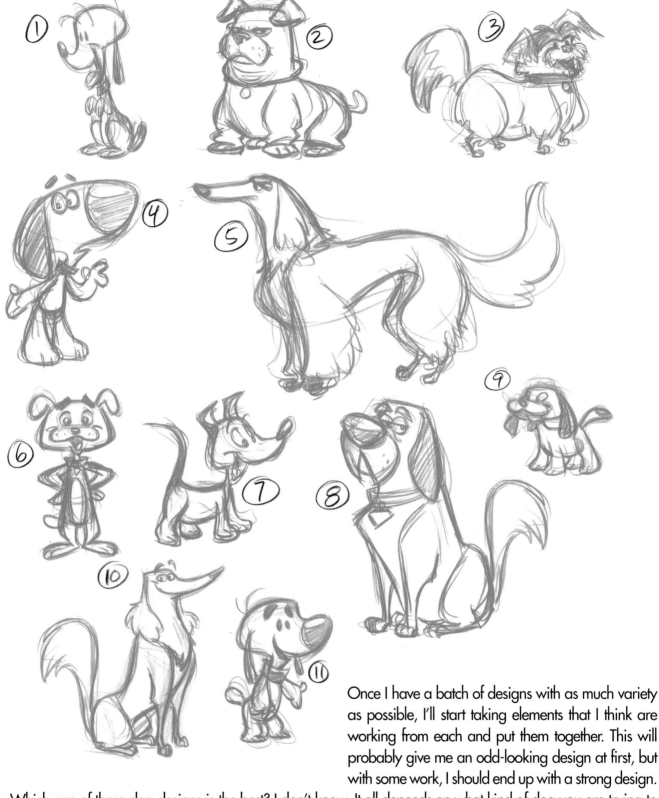

Once I have a batch of designs with as much variety as possible, I'll start taking elements that I think are working from each and put them together. This will probably give me an odd-looking design at first, but with some work, I should end up with a strong design.

Which one of these dog designs is the best? I don't know. It all depends on what kind of dog you are trying to create. Is it supposed to be cute, scary, or wacky? Based on design alone, my favorites are numbers 2, 10, and 11.

Let's begin designing our Western film characters. Start with the lead character, since that design will help establish the look of the film and the character hierarchy (see pages 18–21). Look over the description for Dillon, our unmotivated cowboy, on page 23. Then look at the initial shape lineup you created in Assignment Two, on page 39. With the description of Dillon in mind, you will be able to create a design that really captures your image of our hero.

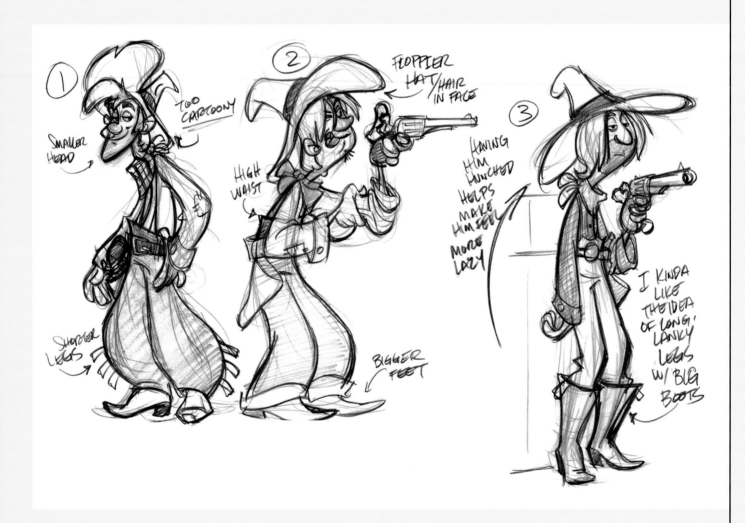

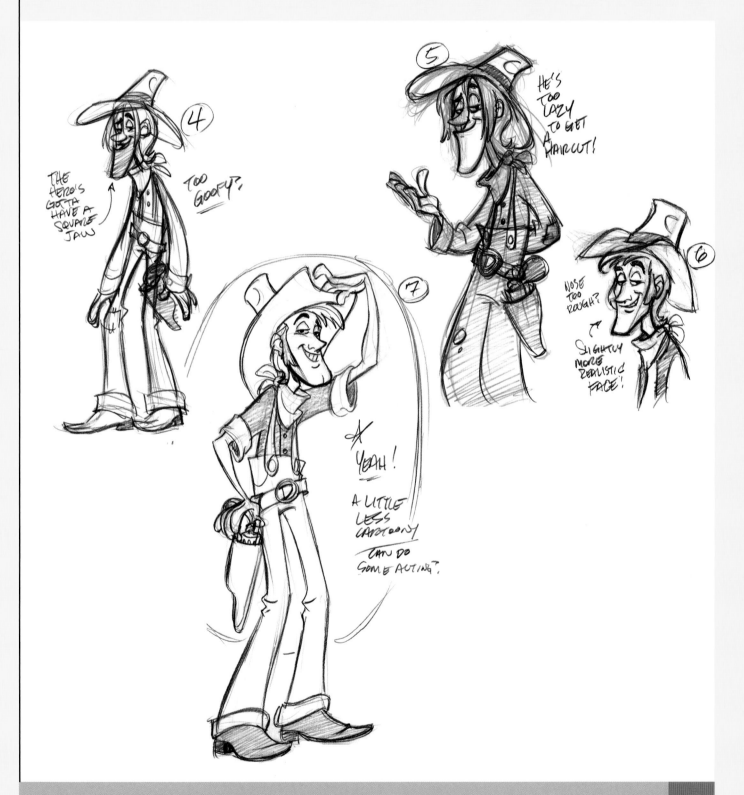

Jack Davis started his career in the Navy, drawing for the *Navy News*. After the Second World War, he attended the University of Georgia, and in 1951, after finishing his continuing studies at the Art Students League in New York City, he joined EC Comics. At EC he worked on such projects as *Mad* and its successor, *Panic*, but he was at his best on the *Small Town Horror Stories*. When EC eventually collapsed, Davis illustrated stories for *Warren* and *Mad* magazines.

Davis has illustrated dozens of album covers and covers for *Time* and *TV Guide*, worked on animated TV shows and advertising campaigns for major companies, and created numerous film posters. Among the many honors that have been bestowed on Davis is the coveted Reuben Award, which the National Cartoonists Society presents to its Cartoonist of the Year. Davis won the award in 2000.

HIS THOUGHTS ON DILLON

First off, yew gotta wanna be a cowboy to draw a cowboy! When growing up yew shoulda seen a whole bushel of Saturday cowboy movies, then later on liked *High Noon*, *Shane*, *Lonesome Dove*, and all the other cowboy movies for grown-ups.

- Read the script to get into it.

- Work on a rough posture outline by drawing a loose stick man or two (and remember, all cowboys have long, skinny, bowed legs).

- Think about the facial expression; feel the character.

- Think about what cowboys wear:

 - A "bandanner," like Festus wore on *Gunsmoke*, way back in the glory days of TV Westerns in the Fifties.
 - "Suspendas" double the protection if the belt don't work.
 - Gun and gun belt make sure these can be seen clearly, and show just a few bullets remaining in the belt, suggesting that he's used the gun recently.
 - Sleeves rolled up halfway, red underwear showing
 - Boots are the leather-strap pull-on kind; britches are tucked in or out; the lower parts of the boots are dusty; and there's a slight shine on the upper part. Don't forget spurs. They show personality.

- And remember, above all, a cowboy loves his hoss!

Jack Davis

comic book artist, cartoonist, and illustrator,
Mad magazine artist

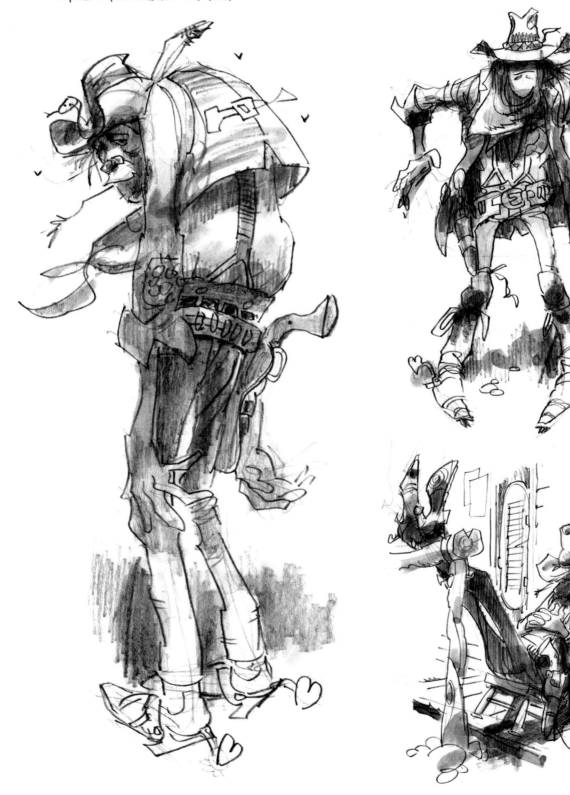

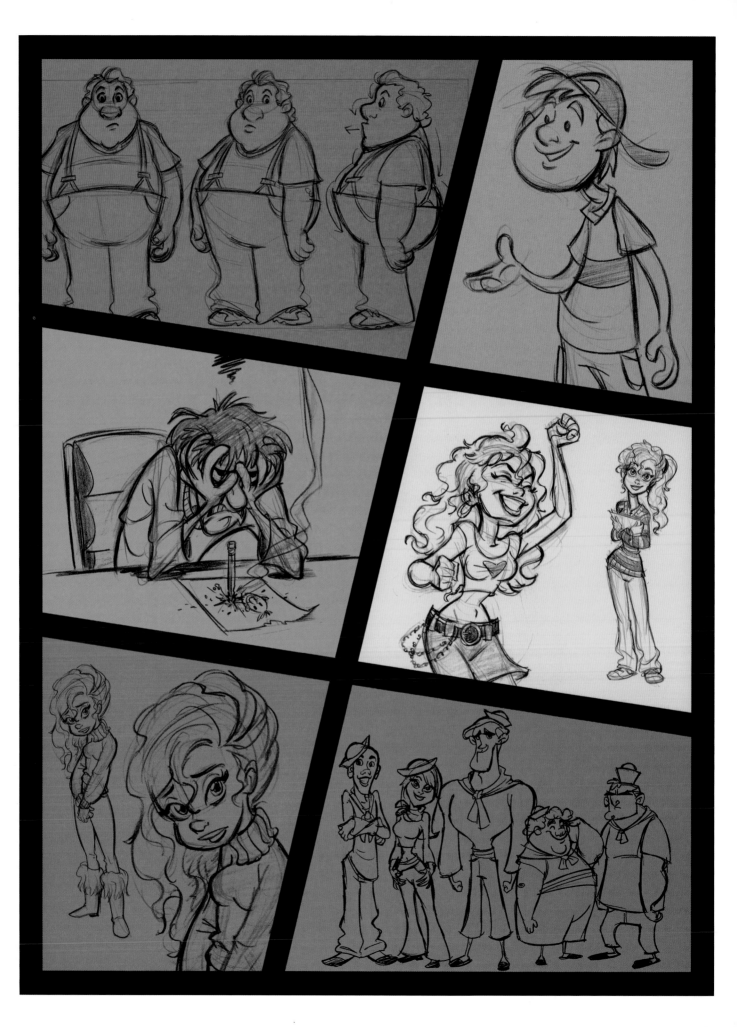

CHAPTER THREE

CREATING APPEALING CHARACTER DRAWINGS

Appeal was a word that we used a lot at Disney. Animators there have passed this term down for decades to describe a character's pose, expression, or movement. Even a prop design can have appeal. A drawing with appeal has that "extra something" that makes it stand out. So, let's look at ways to create a strong appeal in your drawings.

"IT'S SO APPEALING!"

- START WITH A CIRCLE—AGAIN?
- TURNING YOUR CHARACTER IN 3-D
- PUSHING YOUR DESIGN

START WITH A CIRCLE—AGAIN?

You've seen this rule in just about every other how-to book, and I'm going to repeat it here: Start with a circle. Have you ever wondered why you should? For one, even a beginning student can easily duplicate a circle. Also, working with a circle provides an easy way to learn a lot about volume and creating a three-dimensional drawing. From an animation standpoint, it's easier to rotate a circle in three-dimensional space than it is to rotate more complex shapes, such as triangles and squares.

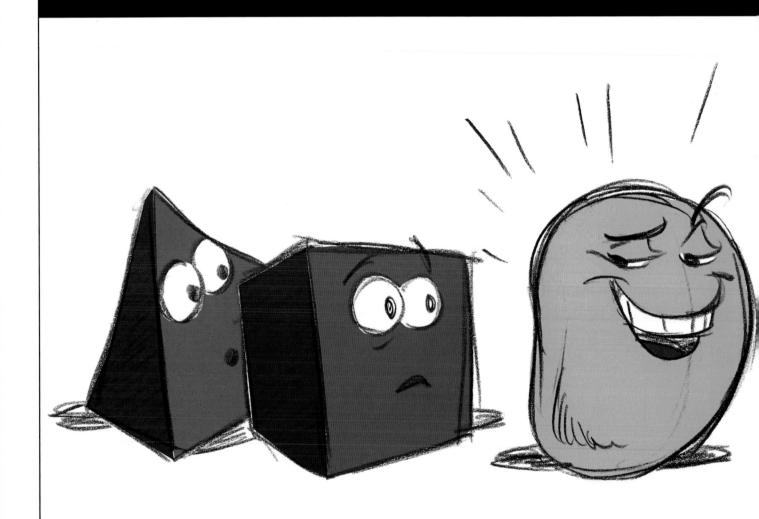

All this said, your character will look boring if you use only circles. So, create your character using circles along with other basic shapes, such as ovals, squares, and triangles. If you stick to these basic shapes, you will be able to duplicate the character easily and quickly from different angles and in different poses. An advantage to working quickly is that you won't waste a lot of time on a character that's not successful—you'll have the luxury of being able to sketch up a character, determine if it's working, and throw it out and start again if it's not. Here are some examples of different characters that use only basic shapes. Even without faces and costume details, you get an idea of what the characters are like.

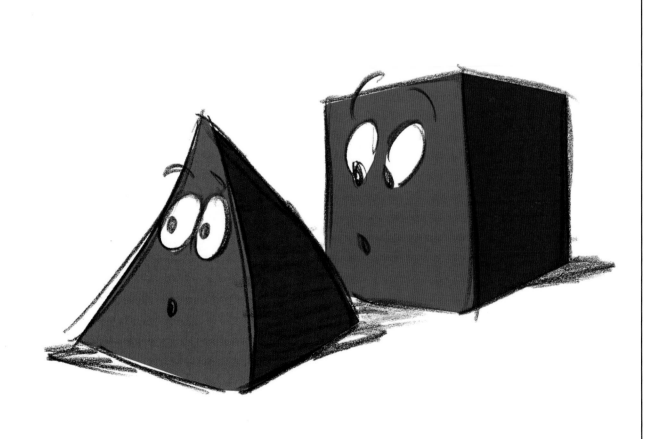

TURNING YOUR CHARACTER IN 3-D

Even seasoned artists often nail a front-view drawing of a character then start a slow descent into insanity trying to draw a side view that looks like the same character. Or, you create different views of a character that work technically but don't have a sense of appeal. Remember, if the front view has a strong sense of design, the side view, three-quarter view, and back view should have a strong design, too. Here are some concepts that can help recreate your character from different angles.

LINE UP!

You've seen the series of drawings of characters with the lines going behind them, right? These horizontal lines run from key points on a character (bottom of the feet, top of the head, chin, eyes, nose, waist, shoulders, knees) so the artists can line up these features when drawing the character from different angles. This is a good way to figure out what your character might look like from different angles while still maintaining a size relationship consistency. Determining how your character will look from different angles is essential to good character design. The problem is that it's very easy to suck the appeal, strength of design, and personality right out of your design as you measure and plot for pinpoint accuracy.

When you begin to design a character, I suggest you draw the front, side, three-quarter, and back views of your character free hand—that is, without the ruled lines into which you try to fit your character. This will enable you to concentrate on the strongest design of your character and the personality implied by the pose and face. Once you are feeling comfortable with the design and personality, you can set out to do the turnaround model sheet, made up of front, side, three-quarter, and back views of the character.

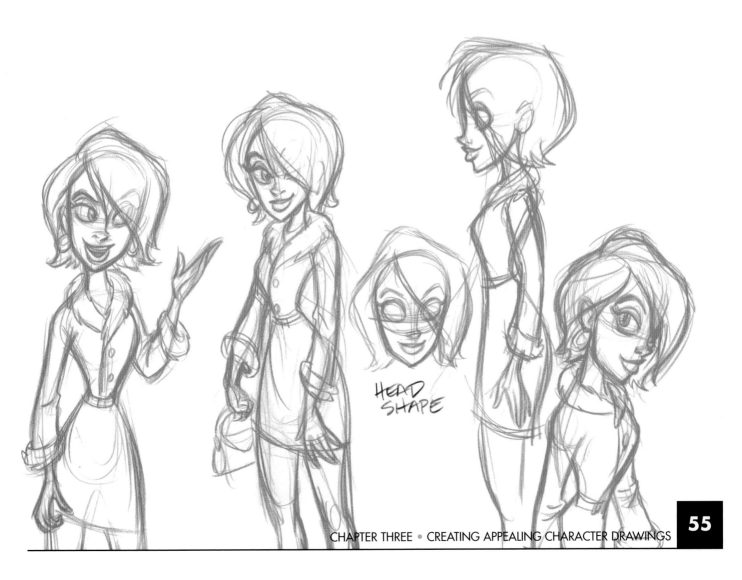

HEAD SHAPE

Here are front views, three-quarter views, and side views of a character. The nose and eyes line up from drawing to drawing for accurate but fairly bland designs.

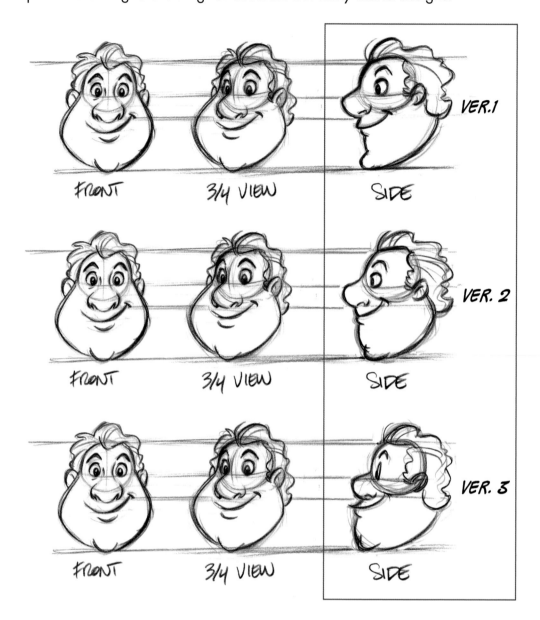

FRONT 3/4 VIEW SIDE VER.1

FRONT 3/4 VIEW SIDE VER. 2

FRONT 3/4 VIEW SIDE VER. 3

Here's a side view that works technically but also has stronger appeal. There is more variety in the shapes, most especially in the chin, mouth, and slope of the nose. Rather than just being a flat side view, this design now has strong silhouette appeal.

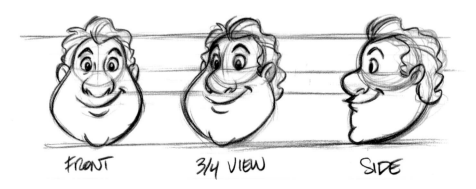

FRONT 3/4 VIEW SIDE

Below are some drawings of the entire body. Note how you can strengthen a side view and a three-quarter view of a character by pushing the appeal and design. By making some elements stick out farther (like the stomach and back side in this case), you will get a stronger silhouette and create more variety in the shapes. The side view will help you determine the widths of the chest, head, and waist. As a result, the side view is where you really start locking down the ins and outs of your design. Sometimes doing the side view will make you want to tweak the three-quarter view as well as front and back views.

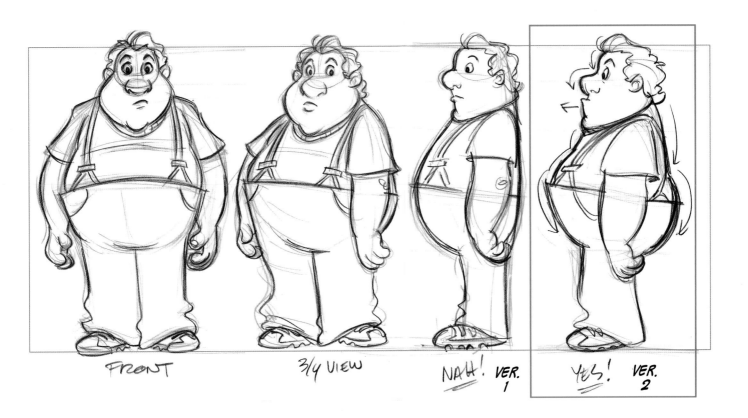

FRONT 3/4 VIEW NAH! VER. 1 YES! VER. 2

PUSHING YOUR DESIGN

Often, you'll create a design, fall in love with it, and decide you're done. Fight that urge. You are most likely only 90 percent of the way to a final design. It's time to push your drawing, put in the extra effort to see if it can be even stronger. Look the drawing over and decide what parts you love and what parts are just okay. Keep what's working, but start designing new parts to replace those that merely get a passing grade.

Here are some examples of how I push a design. Bear in mind that you can push a design too far– to the point that it breaks, or no longer works for the needs of the story. You can decide which of these drawing are stronger and in which I may have gone too far.

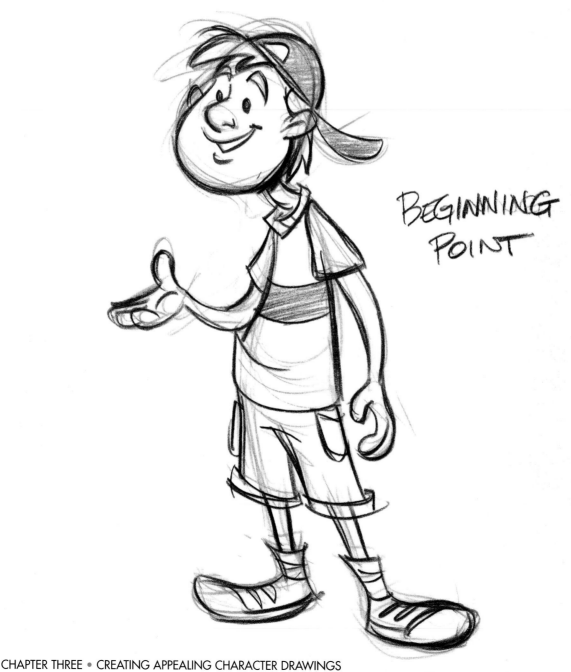

BEGINNING POINT

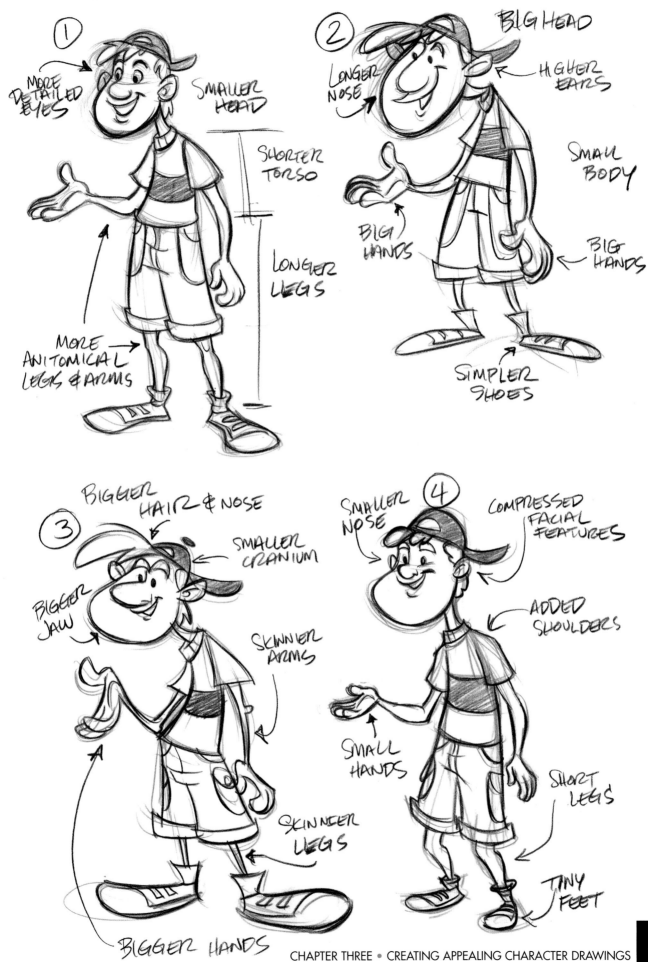

1. MORE DETAILED EYES
SMALLER HEAD
SHORTER TORSO
LONGER LEGS
MORE ANITOMICAL LEGS & ARMS

2. LONGER NOSE
BIG HEAD
HIGHER EARS
SMALL BODY
BIG HANDS
BIG HANDS
SIMPLER SHOES

3. BIGGER HAIR & NOSE
SMALLER CRANIUM
BIGGER JAW
SKINNIER ARMS
SKINNIER LEGS
BIGGER HANDS

4. SMALLER NOSE
COMPRESSED FACIAL FEATURES
ADDED SHOULDERS
SMALL HANDS
SHORT LEGS
TINY FEET

COSTUMES

Do the pants cut across the stomach? Is your character is wearing a turtleneck or tank top, high heels or flats? These clothing choices affect your character design. Clothing says something about the character's personality. Also, the way clothing lays on the body breaks up the shapes of a design. Here's a character clothed in different styles and designs of clothing. Note how each outfit says something different about the character's personality and breaks up the design in different ways.

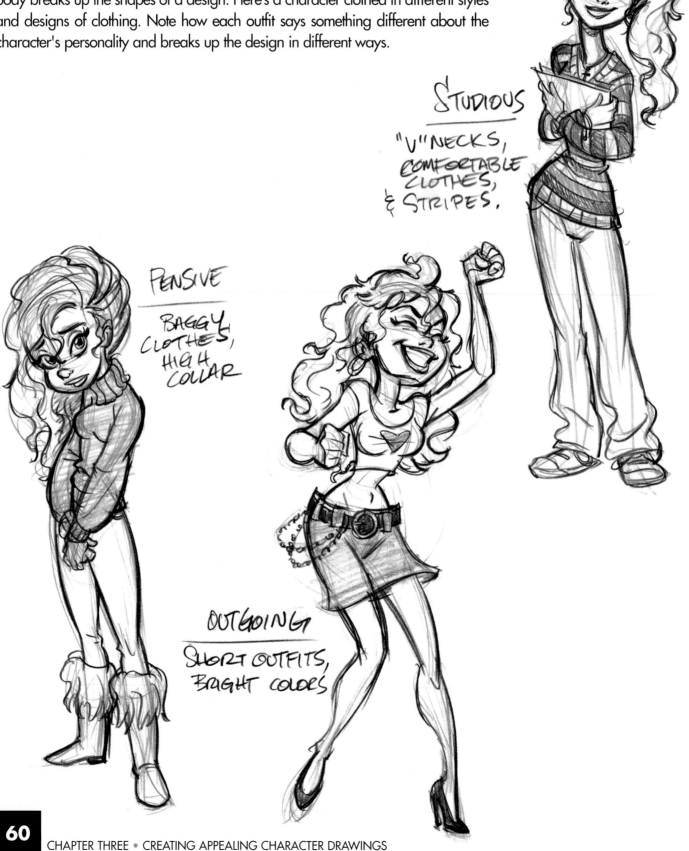

STUDIOUS

"V" NECKS, COMFORTABLE CLOTHES, & STRIPES.

PENSIVE

BAGGY CLOTHES, HIGH COLLAR

OUTGOING

SHORT OUTFITS, BRIGHT COLORS

Sometimes you'll encounter a group of characters of varied sizes wearing the same outfit or uniform. Keep in mind that different body types will wear clothing differently. You can also show a little bit of personality—be it sex appeal, sloppiness, or tidiness—in the way your character wears the same outfit. Here are some different characters who are wearing the same elements of clothing, but wearing them in very different ways.

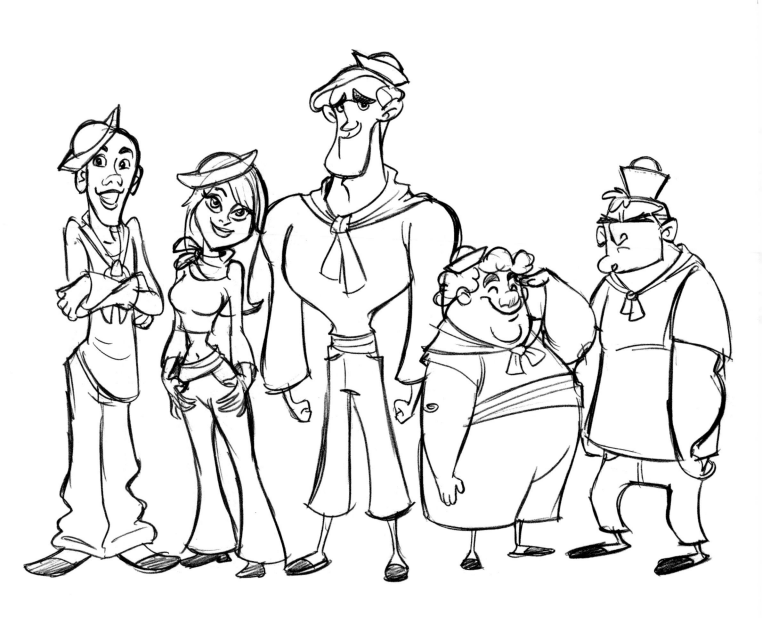

Bill Amend was born in 1962 in Northampton, Massachusetts. He contributed cartoons to his high-school newspaper and literary magazine, served briefly as president of the math club, and played tuba in the school band. He attended Amherst College, where he continued to draw cartoons for the twice-weekly college newspaper. While at Amherst he majored in physics and graduated with honors in 1984. After a brief stint in the animation and motion-picture industries in San Francisco, he decided to pursue cartooning full-time and signed with Universal Press Syndicate in the fall of 1987. His comic strip *FoxTrot* debuted April 10, 1988, and appears in more than a thousand newspapers worldwide. It has spawned more than twenty-one best-selling book collections. In May 2000, Amherst College awarded Bill an honorary doctorate in humane letters. Bill lives in the Midwest with his wife and two young children.

HIS THOUGHTS ON DILLON

Here's my *FoxTrot*/Bill Amend rendition of the Dillon character. There wasn't a specific age given in the treatment for the film, but I guessed Dillon would be somewhere from 16 to 20. Generally, I try to avoid tall characters in my strip, as that tends to eliminate a lot of the space I need for dialogue, so I didn't exaggerate the character's height too much. I gave him unkempt hair and an untucked shirt to convey his laziness, and I tried to give him a shirt and pants that were a little too big for his frame.

With a comic strip, you try to simplify everything as much as possible, so I "sewed" the one little patch on his hat to convey that he wasn't particularly well-off financially (by the way, cowboy hats always give me headaches when I have to draw them). The little thing hanging from his pants on a string is a compass, which I figured would come in handy during his treasure hunt. I didn't give him a gun and holster, as I don't think newspapers would want that as an everyday part of his outfit, and it seemed to take away some of the "heart of gold" appeal we're after. With my daily strip, the color palette is limited pretty much to white, black, and gray, so I'd probably leave the shirt white and make the boots gray and the pants black (or a darker gray if I had that option). The hat would probably stay white just because he's a good guy, and we'd want to use every convention we could to convey that. This was fun.

Bill Amend

CREATOR, WRITER, ARTIST, FOXTROT

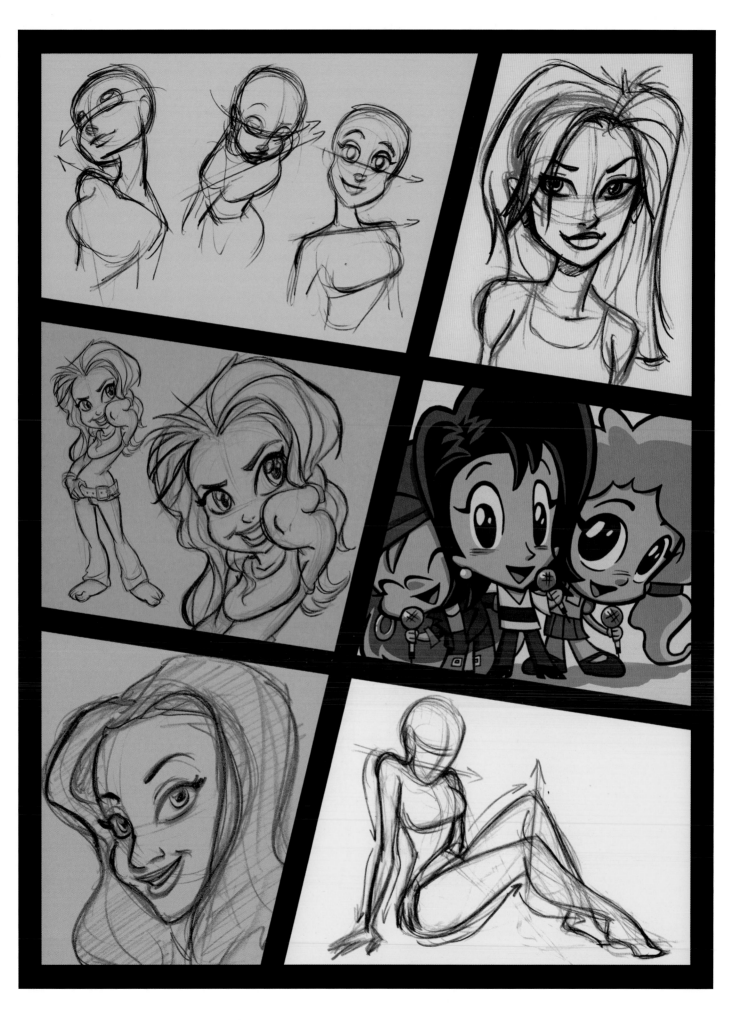

CHAPTER FOUR

Drawing (Beautiful) Women

In this chapter we'll consider some of the different principles of drawing appealing women. At the outset, and while still keeping this book kid-friendly, I want to say that there are certain proportions, curves, and facial features with which you can endow your women to ensure that they will be appreciated by any "romantically inclined" viewer.

IN THE EYE OF THE BEHOLDER

I will never forget the hardest question I was ever asked in an interview. I was at Disney, we had wrapped on Mulan, and it was time to do a major media blitz for the Asian market. Reporters from various newspapers and magazines in China were meeting with us animators in a little room set up for interviews. They were very polite and gracious, but as soon as they started in on their questions, I realized they were trying to push an angle. I was told later that the Chinese reporters did not think that Mulan was attractive enough. They didn't even think she looked Chinese. Their questions were aimed at finding out what Americans think is beautiful. They were fishing around for a good sound bite. (Keep in mind, I was the animator of Mushu, the funny little dragon, not Mulan, the lead female character.)

One of the reporters boldly asked, whom do you consider to be beautiful? Thrown off guard, my mind spinning, I tried to think of a beautiful celebrity they might also consider beautiful. Names like Demi Moore, Meg Ryan, and Cindy Crawford came to mind—then it hit me!

I quickly answered, "My wife."

They all laughed, and my quip helped dispel some of the tension in the room.

I learned two things that day. When applied to drawing women, the concept of beauty varies a lot, but at the same time, there are some elements of feminine beauty that are pretty much universal.

PROPORTIONS

Just like an assortment of real people, designed characters can have a wonderful variety of body proportions. Here are some general "rules of proportion" you can follow when creating designs for different types of attractive women.

LARGE HEAD, SMALL BODY
This approach lends cuteness to a character, as these are the proportions of small children.

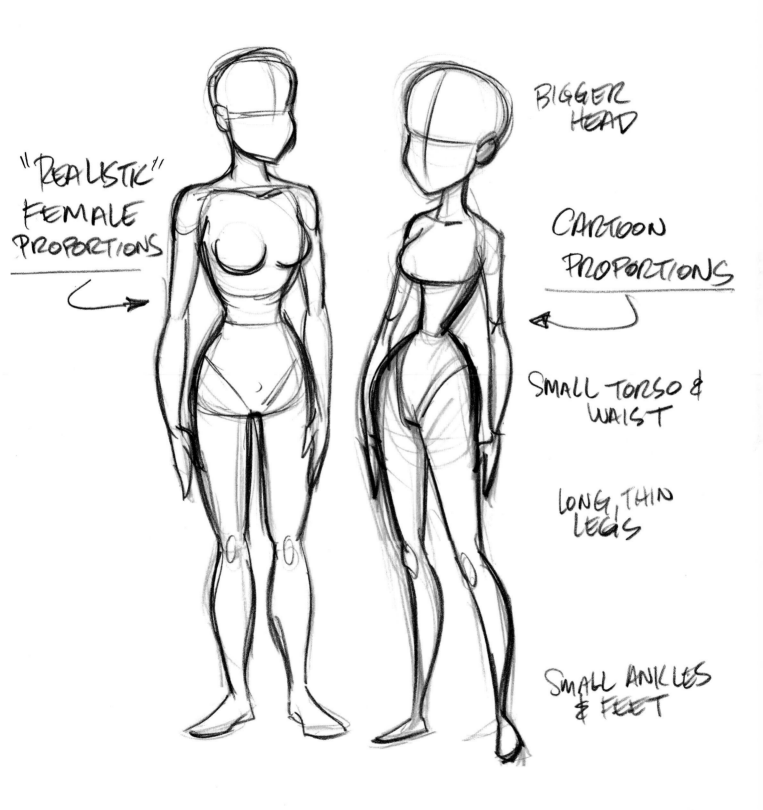

"REALISTIC" FEMALE PROPORTIONS

BIGGER HEAD

CARTOON PROPORTIONS

SMALL TORSO & WAIST

LONG, THIN LEGS

SMALL ANKLES & FEET

LARGE, EXPRESSIVE EYES WITH LARGE PUPILS, A SMALL, PERT NOSE, AND A SMALL MOUTH WITH THICK LIPS

How you place those elements on your character's uniquely shaped face (no two human faces are shaped alike) will create variety in your designs.

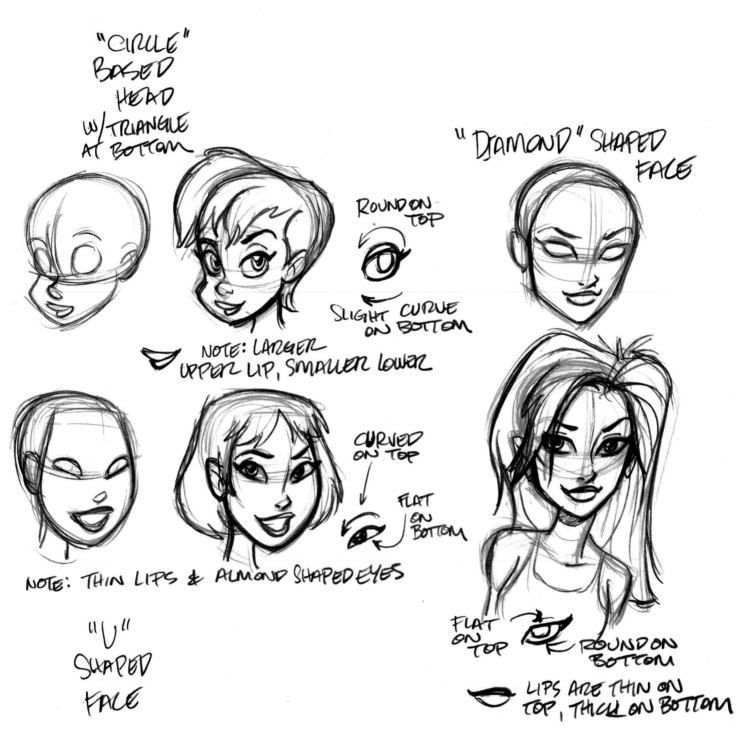

"CIRCLE" BASED HEAD W/ TRIANGLE AT BOTTOM

"DIAMOND" SHAPED FACE

ROUND ON TOP

SLIGHT CURVE ON BOTTOM

NOTE: LARGER UPPER LIP, SMALLER LOWER

CURVED ON TOP

FLAT ON BOTTOM

NOTE: THIN LIPS & ALMOND SHAPED EYES

"U" SHAPED FACE

FLAT ON TOP

ROUND ON BOTTOM

LIPS ARE THIN ON TOP, THICK ON BOTTOM

FOR VARIETY . . .

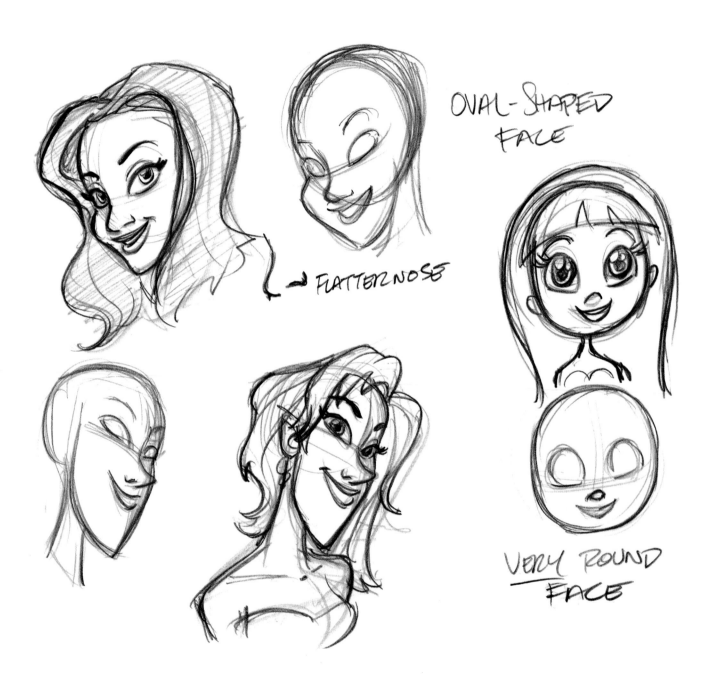

OVAL-SHAPED FACE

FLATTER NOSE

VERY ROUND FACE

CURVES AND RHYTHM

The most important rule: Construct your female characters with curved lines. When you feel the need to draw a straight line, *don't*—just make a line that's less curved. (And, in this vein, when drawing comic book superheroines, don't overdo the muscles, or you will loose the appeal of the female form.) Notice that in the forms shown here, one side is straighter while the other side is more curved. This design concept creates a natural flow and rhythm throughout the body. Notice also the curves and rhythm in the lines of these drawings. Even in rough form, they create a feeling of grace and elegance that is naturally evident in the female form.

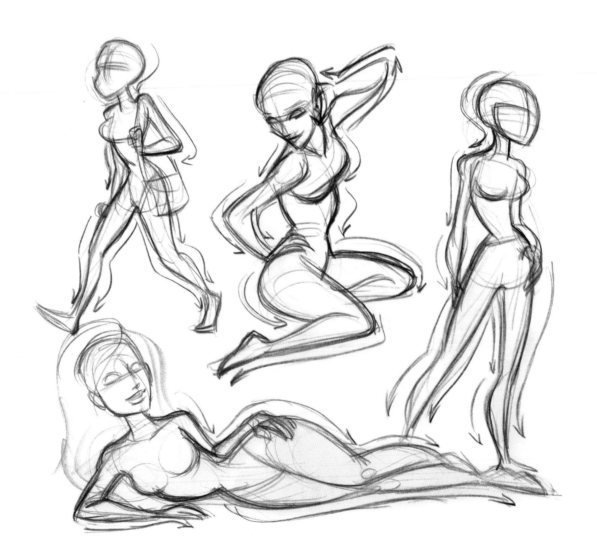

TILTS

When posing your character, look for ways to work tilts into the pose. By tilts I mean the opposing angles in which you place parts of the body. You create visual interest in a design—and therefore a pose—by opposing the tilts within the pose. If the right shoulder is higher than the left shoulder, then the left hip should be higher than the right hip. This will create a pinch on the left side of the body and a stretch on the right side. Not only will this make the pose more interesting, but it will accent and push the character's curves.

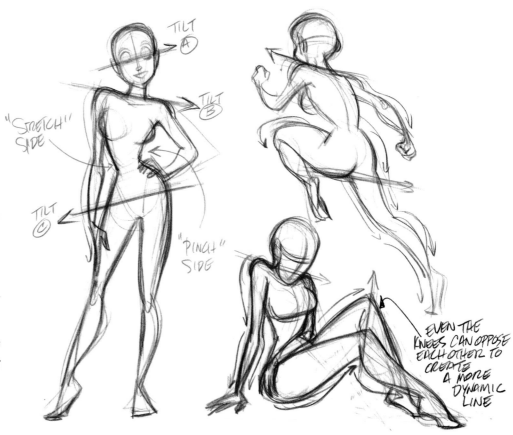

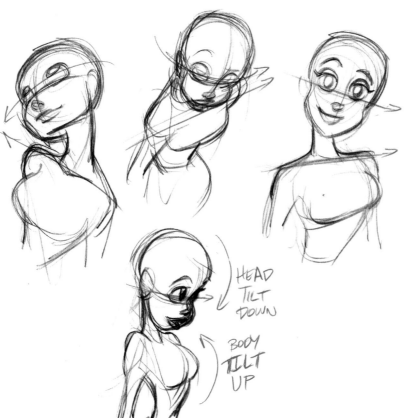

When I animate, I am constantly looking for places to add tilts to my poses. Doing so always strengthens a pose and creates more rhythm. Just tilting the head can make your character project more femininity. Tilts also add drama and appeal.

FACES AND EYES

We've all seen the work of artists who can draw really beautiful women, but all their women characters look alike. It can happen easily—you find something that works and you stick with it. As a character designer, you don't want to fall into that trap. Round shapes are generally the norm for pretty girls, but try to find other shapes to create variety in your female characters—long faces, sharp chins, square faces, large cheekbones, round chins, you name it.

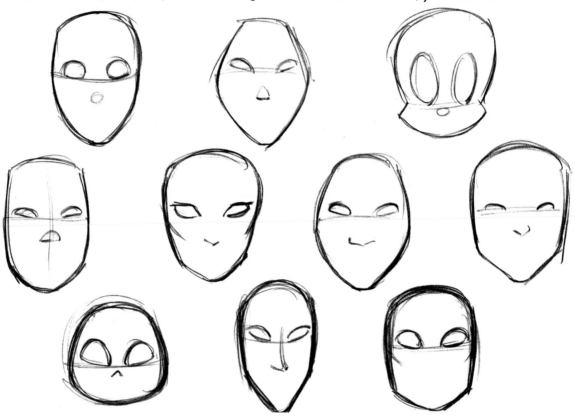

It's easy to find a shape for the eyes that works—and then just keep repeating it. Don't. There are many different eye shapes out there: almond, round, oval, slightly angled. And any of these can be framed by thick lashes or thin lashes. The sky is the limit, and these different shapes add variety and interest to your design Remember, variation in eye shape is pivotal when creating women of different races, too.

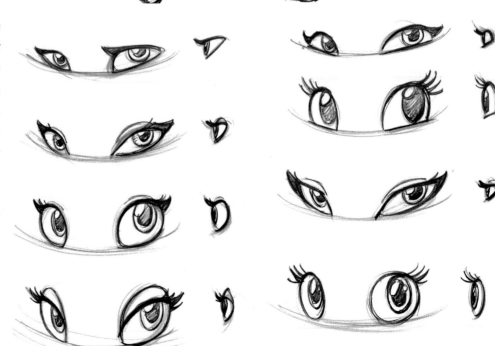

HAIRSTYLES AND CLOTHING

If you are a typical macho male, believe me, no matter what you think, you don't know women's hairstyles or clothing. On a personal note, that's why I depend on my wife when my four daughters ask things like: Can you do my hair? Does this match? If you're like most male illustrators (and women illustrators aren't immune to this, either), I can tell you that you will run out of ideas after your second or third designs. That's why it's important to surround yourself with women's fashion magazines. They are chock-full of up-to-date fashion ideas.

Hairstyles can be difficult to draw. You don't want to draw every strand, so you will need to find a simplified way to show realistic-looking hair. When we were animating the character of Pocahontas in the movie of the same name, we used to say her hair was the co-star of the film. After all, it was everywhere and as hard to animate as she was.

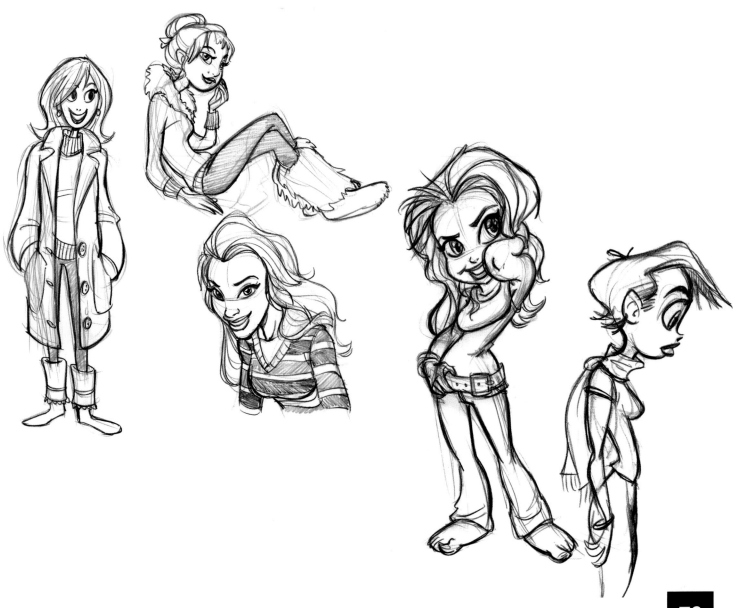

TRYING IT OUT

For fun, I took on the challenge of trying to create a stylized cartoon version of a pop group my kids like, as if the design would be used on stickers or tee-shirts. This is a tougher challenge than just creating a cute, iconic female character, because these characters should sum up the personalities—if not the looks—of these real people. Keep in mind, my goal was not to create caricatures of these three ladies, but to create characters that represented them—without looking like them too literally.

My first goal was to try and find shape and personality differences of the three members that I could expand upon. This was pivotal to ensuring that the characters would have individuality even though they would always be shown together. Step one was to look at photographs and do a drawing that was somewhere between realism and cartooning. With this first drawing, I was trying to find the different shapes that I would push in subsequent designs.

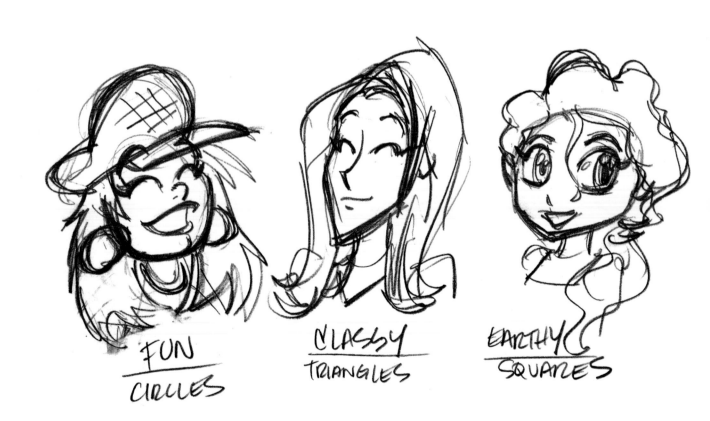

FUN
CIRCLES

CLASSY
TRIANGLES

EARTHY
SQUARES

I then took my ideas and created a Manga-inspired version, because Manga style is very popular with kids in the age group I was designing for. While drawing this version, I tried to push the shapes while showing the differences between the characters and maintaining a consistent style.

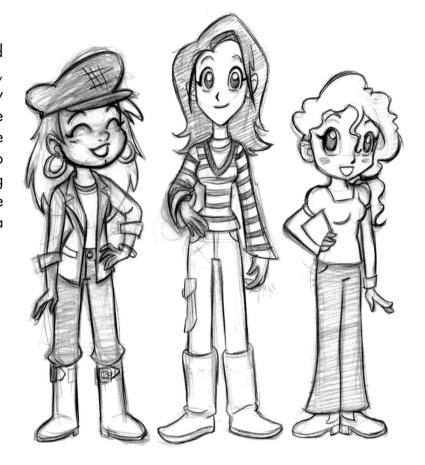

I was pretty happy with my direction, but the design wasn't yet where I wanted it to go. I liked the manga influence, but I wanted "cute" to be the first impression someone had of the characters. After all, the majority of the group's fans are preteen girls. So, I looked at the Manga characters called *chibi*. They have big heads, small bodies, and huge eyes.

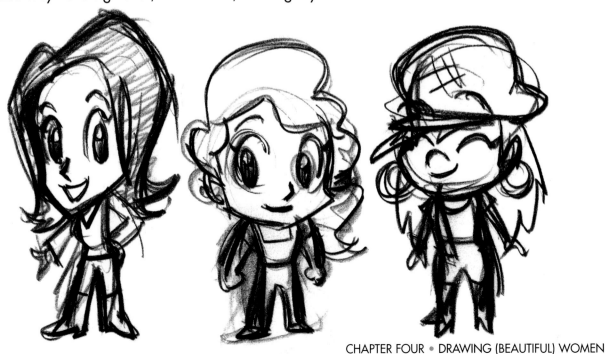

After doing a little more research on that style, I came up with more designs, shown below. Aha! This was what I was looking for: a stylized representation of the trio that had extreme cutesiness value while still being "cool."

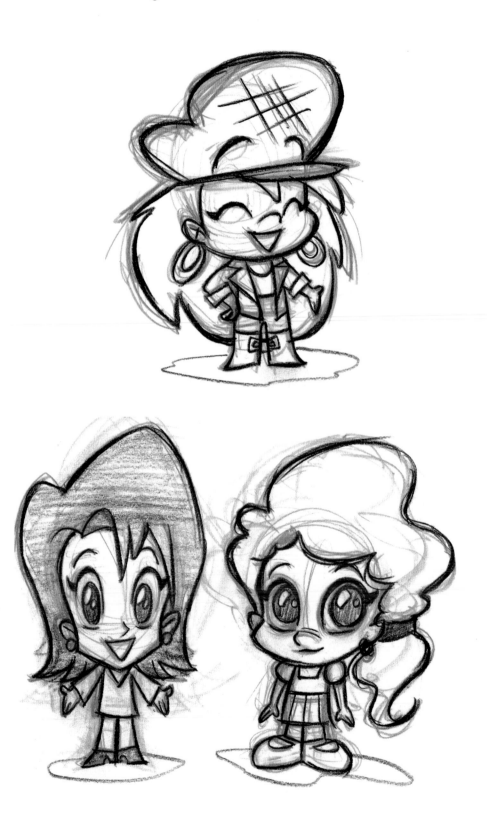

I then drew up a design that showed the group, and I did a color version. If this was a job for a client, this is what I would have turned in as my final drawing.

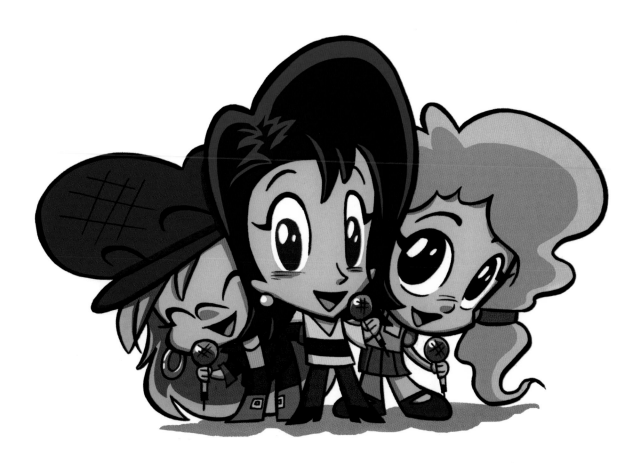

Now let's design the female lead for our film, Polly. We'll use what we've just learned about proportions, curves, and rhythm; tilts, faces, and eyes; and hairstyles and clothing. Before you begin, refresh your memory about Polly and her role in the film (see page 23). Here are some of my sketches and comments on Polly.

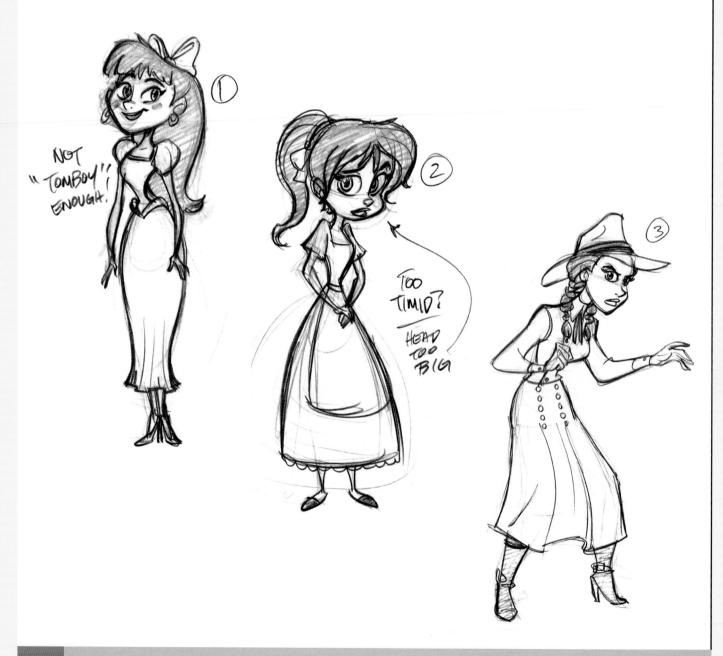

NOT "TOMBOY" ENOUGH!

TOO TIMID? HEAD TOO BIG

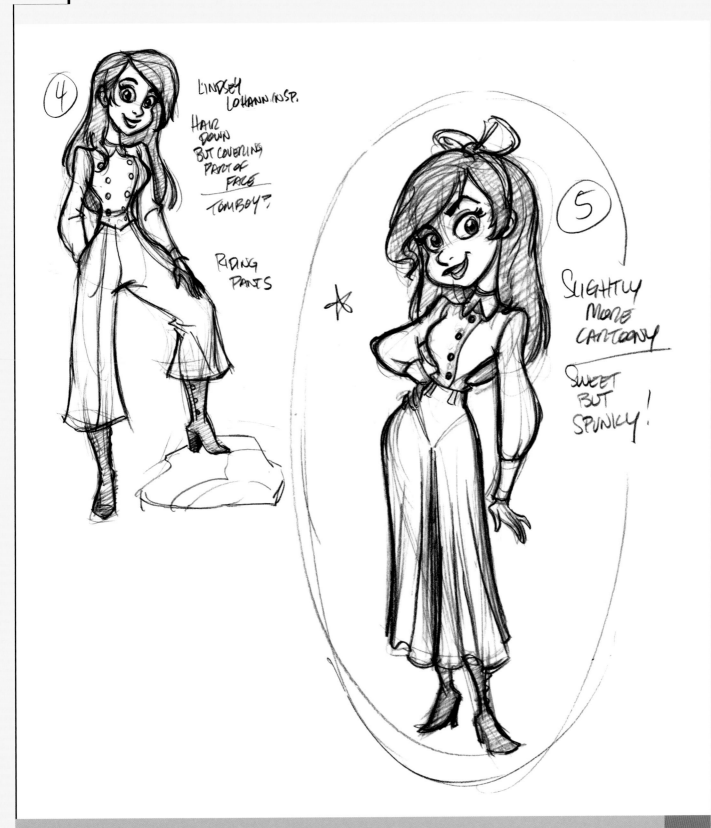

Mark Henn is a twenty-five-year veteran of Walt Disney Feature Animation, where he has been supervising animator on animated films, commercials, short films, and special projects. He has contributed to or created the final character designs of some of Disney's most enduring characters, including Basil of Baker Street and Dawson from *The Great Mouse Detective*, Jasmine in *Aladdin*, Young Simba in *The Lion King*, Mulan in *Mulan*, and Grace in *Home on the Range*. Additionally, he directed the award-winning animated short film John Henry. He has been nominated for an Annie award three times.

HIS THOUGHTS ON DILLON

I began with a lot of information about Dillon. Right away an idea popped into my head. I wanted to come up with a simple shape, hopefully a nice, simple graphic shape that, if colored in black, you would still recognize as Dillon. One of my first thoughts was to make him bowlegged. I figure he had spent a lot of time in the saddle. It's also a classic Western image.

I tried to give Dillon a strong jaw. He is, after all, our hero, and we don't usually like heroes who look too weak. On the other hand, I didn't want Dillon to be a Superman type either. Dark eyebrows help to define his expressions, especially since he has blonde hair. I chose to work with some fairly standard looks for his clothing. A pair of pants, vest, cowboy hat (slightly large), and, of course, cowboy boots.

Research on costumes and props can be fun. It adds a level of authenticity to our characters and helps them to be more believable. I patterned Dillon's gun after an authentic gun of the period, an 1875 Remington revolver. The goal, of course, is to create an appealing character that can also be drawn by the many artists who work on an animated film.

Mark Henn

Supervising Animator, Disney Feature Animation

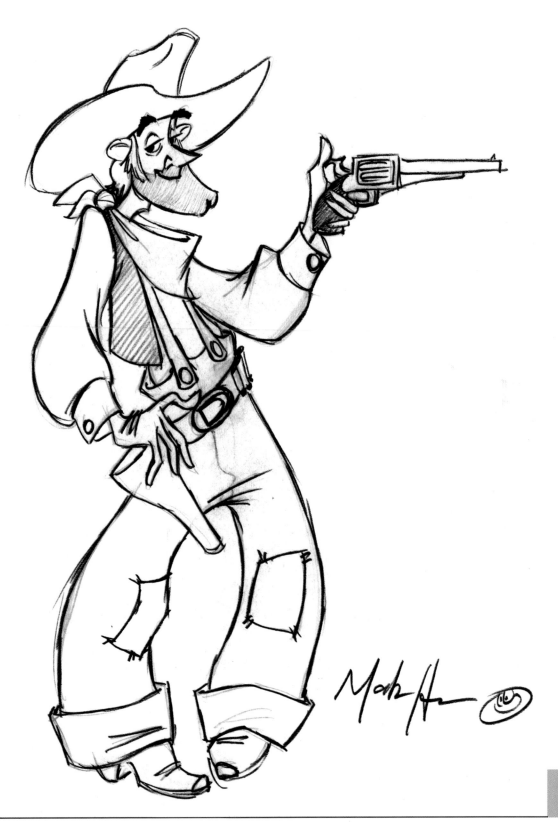

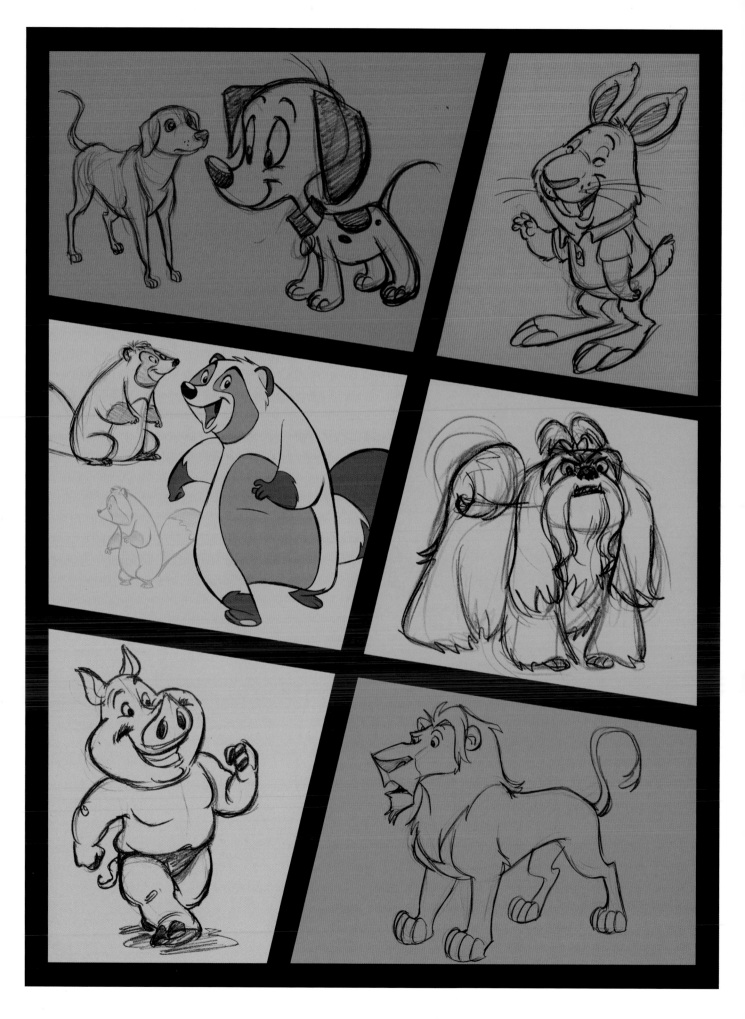

CHAPTER FIVE

FOUR LEGS: A WHOLE DIFFERENT ANIMAL

When designing animal characters, first you need to address the balance between human and animal attributes the character will display in its personality and behavior. Knowing if the character is more like an animal or a human will guide you in how realistic or cartoonish your animal design should be. If the character is more animal-like, then you will naturally want to give your design realistic anatomy; if the character has a lot of human characteristics, then you will most likely design the animal in an anthropomorphic way.

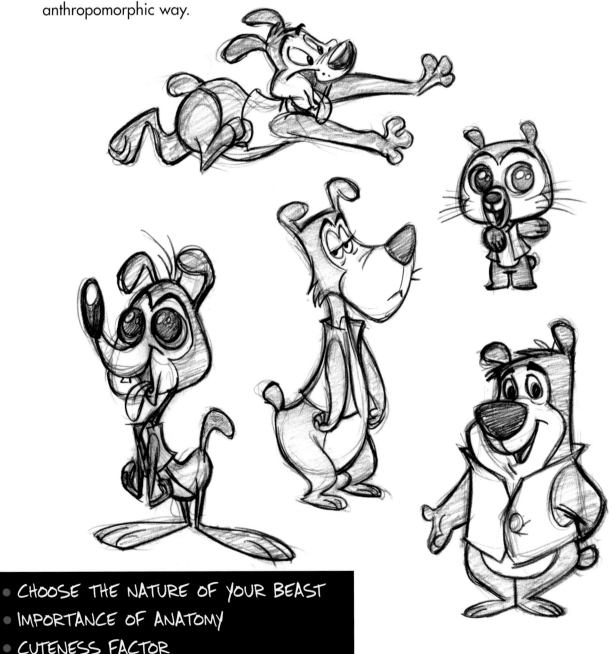

- CHOOSE THE NATURE OF YOUR BEAST
- IMPORTANCE OF ANATOMY
- CUTENESS FACTOR

CHOOSE THE NATURE OF YOUR BEAST

Here are varying levels of human and animal elements and anatomy. These are just examples to show the subtleties of anthropomorphic versus realistic anatomy; you can combine these characteristics in many different ways.

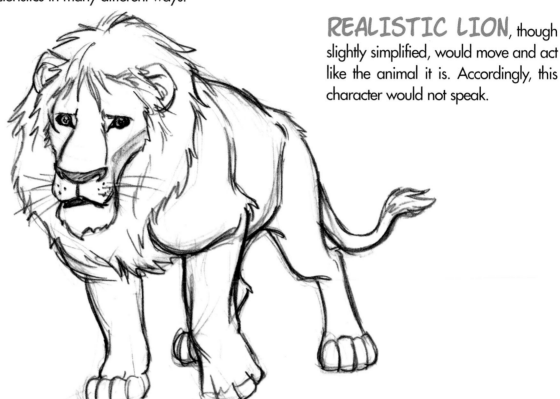

REALISTIC LION, though slightly simplified, would move and act like the animal it is. Accordingly, this character would not speak.

FEATURE FILM LION could speak and act a bit, too, since the human eyes and eyebrows are expressive. With this realistic body, the character would move like a lion and, most likely, not gesture with the paws as if they were hands.

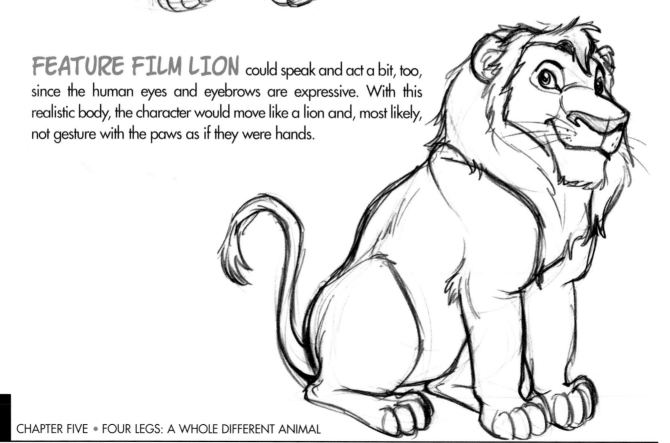

CHAPTER FIVE • FOUR LEGS: A WHOLE DIFFERENT ANIMAL

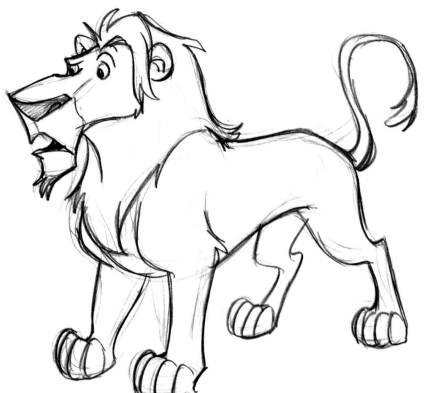

SIMPLIFIED LION has a somewhat realistic body and head, but the features and anatomy have been simplified and stylized. This character probably would not stand on two legs but would not look unnatural doing some humanlike gesturing with its paws.

CARTOON LION has a mane, pawlike hands and feet, and a tail, but in other ways is a human. This character will walk, talk, eat, and often even wear human clothing.

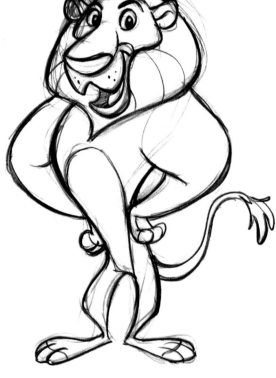

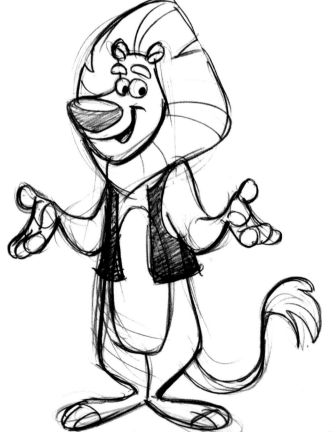

ANTHROPOMORPHIC LION has many of the attributes of a real lion, but it stands on two legs just like a human and can point and make other human-style gestures with its handlike paws and opposable thumbs.

As an animator you discover very quickly the importance of knowing the basic anatomy of the animal you are drawing. My first scene for *The Lion King* was supposed to be easy, a way to "warm up" for drawing the character. In this sequence Young Simba is being chased by the hyenas after the death of his father. He ends up trapped at a cliffside and decides to throw himself over the edge into a briar patch. The scene calls for Simba to tumble down the side of the mountain. The good news (for me) was that Simba would be in constant motion in the scene, so the audience wouldn't have time to scrutinize my individual drawings. The bad news—I quickly discovered—was that I had to draw him from every conceivable angle as he twisted and turned his way down the cliff! By my second drawing, I was throwing myself into any lion anatomy book I could find! To my knowledge, no moviegoer asked for his or her money back based on the weakness of that scene, so I guess it worked out in the end.

I learned that I couldn't draw, much less animate, an animal character without a good knowledge of that animal's anatomy. Neither can you. This means doing research. Go online, go to the library and find books on the animal, go to the zoo, do whatever it takes.

For a comic book project my partner and I were designing, we needed to create an Asian raccoonlike animal called a chikubanotomo, a moniker that the writer, Andrew Simmons, shortened to Tomo when he named our character. These are real animals, so we needed to do our homework before we designed Tomo. We had to be especially careful to make sure Tomo didn't look like a generic raccoon, since the chikubanotomo is actually a member of the dog family. Here's how Tomo evolved. Notice that we started with a realistic design and simplified Tomo as we got a better grasp of his anatomy and what could be stylized.

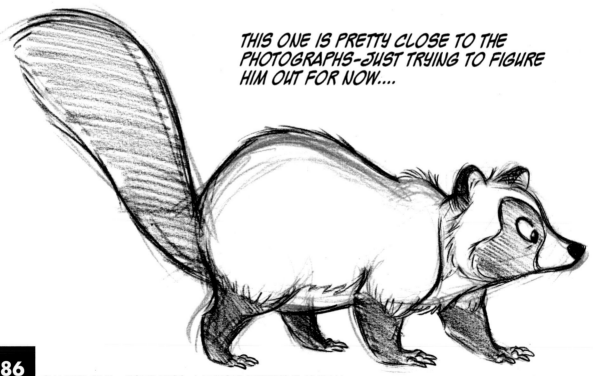

THIS ONE IS PRETTY CLOSE TO THE PHOTOGRAPHS—JUST TRYING TO FIGURE HIM OUT FOR NOW....

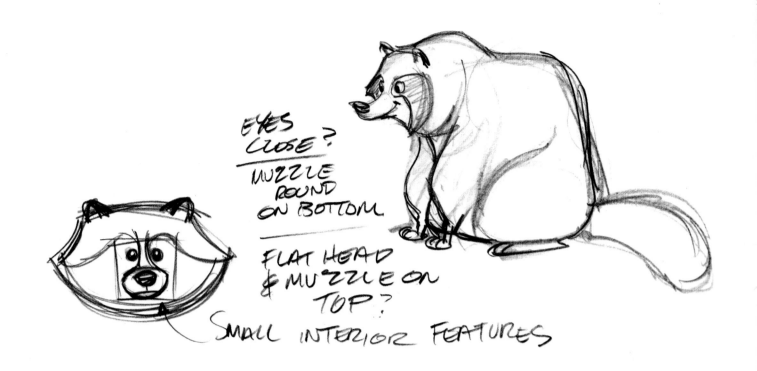

EYES CLOSE?

MUZZLE ROUND ON BOTTOM

FLAT HEAD & MUZZLE ON TOP?

SMALL INTERIOR FEATURES

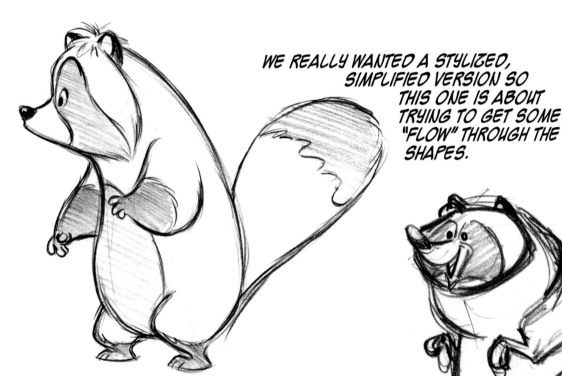

WE REALLY WANTED A STYLIZED, SIMPLIFIED VERSION SO THIS ONE IS ABOUT TRYING TO GET SOME "FLOW" THROUGH THE SHAPES.

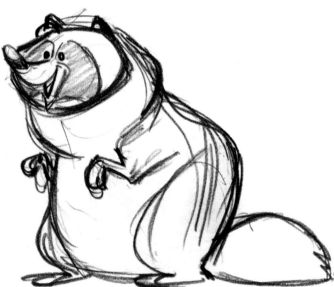

THEY HAVE THESE WEIRD NECKS- NOT AT ALL LIKE RACCOON

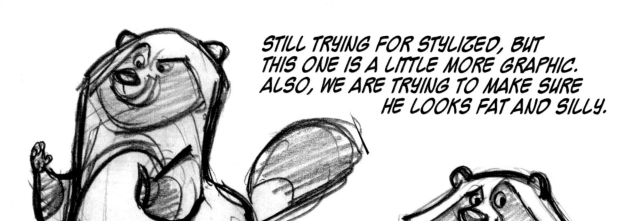

STILL TRYING FOR STYLIZED, BUT
THIS ONE IS A LITTLE MORE GRAPHIC.
ALSO, WE ARE TRYING TO MAKE SURE
HE LOOKS FAT AND SILLY.

NICE AND FAT, BUT NOW THE DESIGN
IS STARTING TO GET TOO "CLUNKY."
I'M MISSING SOME OF THE
SMOOTH DESIGN OF SOME OF
THE EARLIER DESIGNS.

THIS ONE IS FUN AND
WE ARE REALLY STARTING
TO FEEL LIKE IT'S GETTING
CLOSE NOW. STILL,
THE SENSE OF "FLOW"
COULD BE STRONGER.

THIS ONE FEELS RIGHT! IT HAS THE STYLE AND FLOW WE WANT AND LOOKS SILLY TOO!

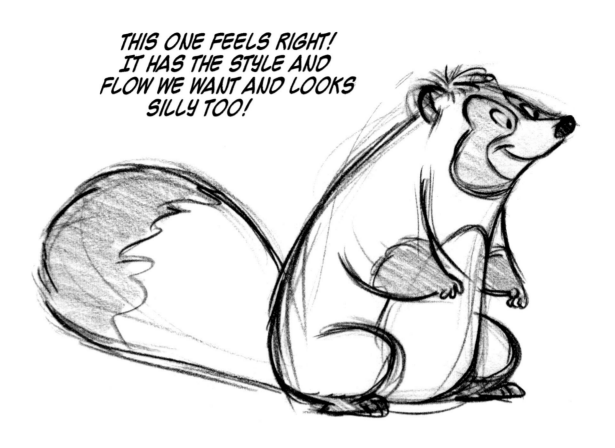

FINAL COLOR

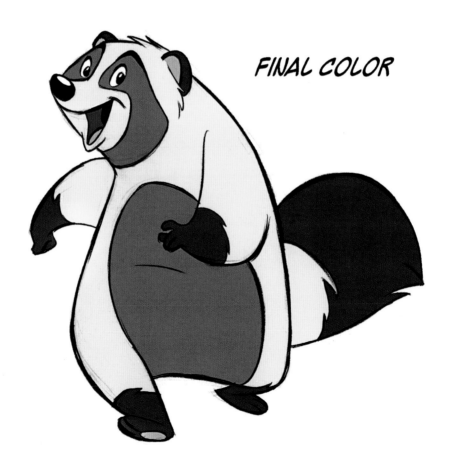

CUTENESS FACTOR

Most of the time, animal characters are cute sidekicks to the main character in a story. Sometimes they provide comedy relief. So, in many cases, you will want to make your animals appealing and cute. As we learned to do with humans (see page 66–69), start out by playing with the proportions. Drawing a big head and a small body is one way to make a design cute. Big eyes and little noses help, too.

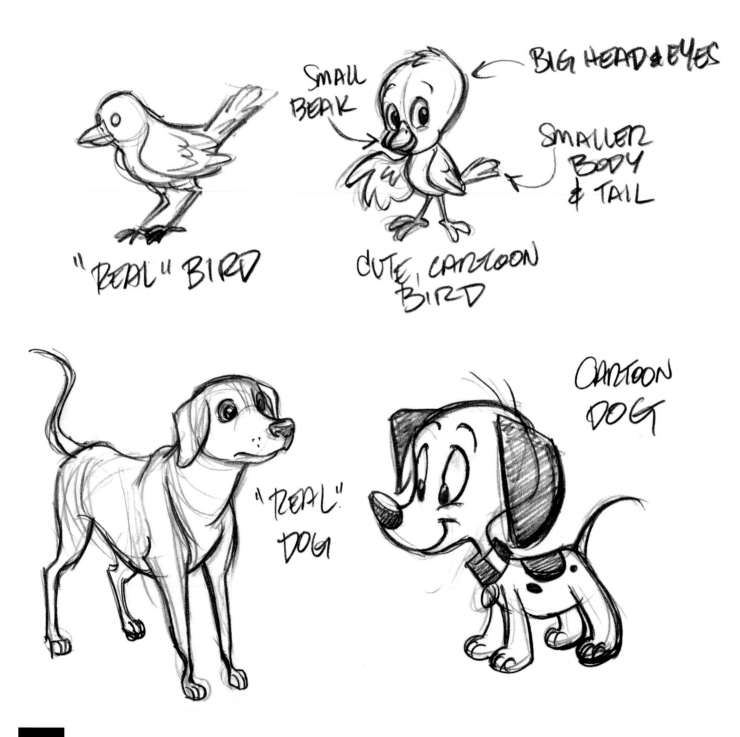

SMALL BEAK

BIG HEAD & EYES

SMALLER BODY & TAIL

"REAL" BIRD

CUTE, CARTOON BIRD

"REAL" DOG

CARTOON DOG

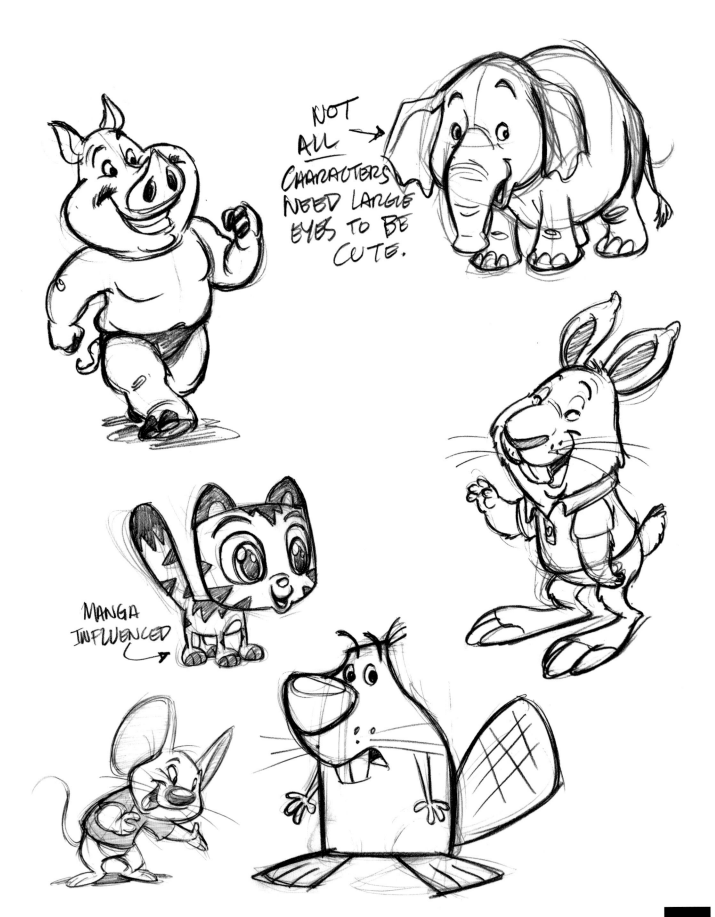

NOT ALL CHARACTERS NEED LARGE EYES TO BE CUTE.

MANGA INFLUENCED

Design Carrots, Dillon's horse, and Ruthie, Polly's dog. Read the descriptions for these humorous characters on page 23 and start creating some designs. Note: Both are humorous, but not in the same way—Carrots, for one thing, is pretty stubborn and ready to argue with Dillon, while Ruthie has a big crush on our hero.

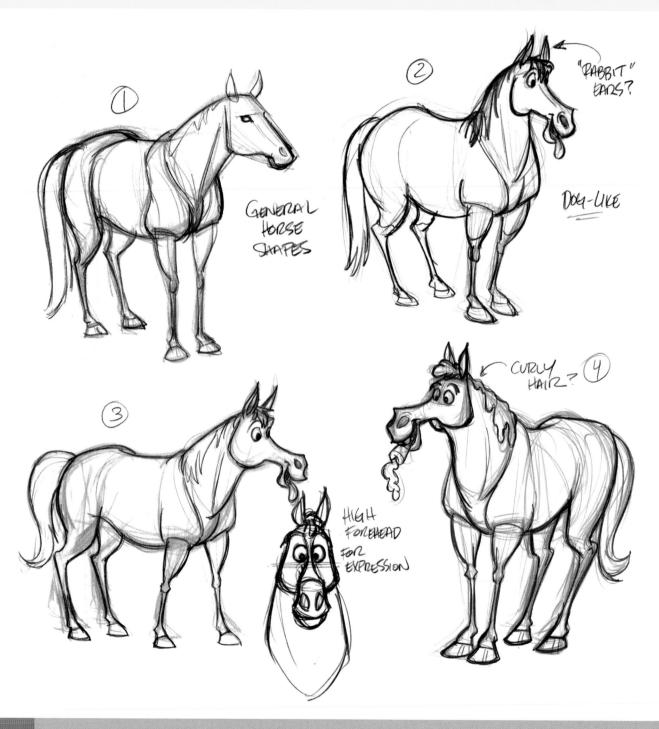

① GENERAL HORSE SHAPES

② "RABBIT" EARS? DOG-LIKE

③ HIGH FOREHEAD FOR EXPRESSION

④ CURLY HAIR?

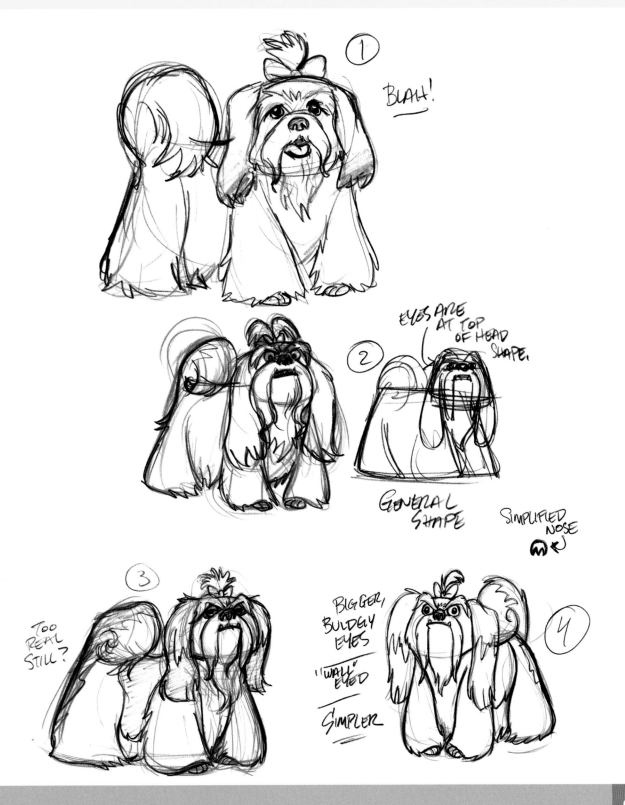

1 BLAH!

2 EYES ARE AT TOP OF HEAD SHAPE.

GENERAL SHAPE

SIMPLIFIED NOSE

3 TOO REAL STILL?

4 BIGGER, BULGGY EYES

"WALL" EYED

SIMPLER

In his twenty-year career, Peter de Sève has been published by many major American magazines, including *Time, Newsweek, Atlantic Monthly, Smithsonian, Premiere,* and *Entertainment Weekly*. He also frequently contributes covers to the *New Yorker*. De Sève has designed posters for Broadway shows, as well as characters for numerous animated feature films produced by Disney, Dreamworks, Pixar, and Twentieth Century Fox (Blue Sky Studios). His credits include *The Hunchback of Notre Dame, The Prince of Egypt, Mulan, A Bug's Life, Tarzan,* and the box office hit *Ice Age,* for which he created all of the characters. He lives in Brooklyn, New York, with his wife, Randall, and their daughter, Paulina.

HIS THOUGHTS ON DILLON

While designing Dillon I tried to keep in mind the essentials of his character that the outline provided. I see him as somewhat of an innocent but perfectly able to muster some anger if need be. When I design a character, I often include drawings that are not necessarily what you'd expect from how he is described. For instance, if I were to design a villain for a film, I would include drawings of him weeping and smiling, not just with the standard-issue sinister glare. The most interesting characters are always the ones with more depth than meets the eye. So when drawing a good guy like Dillon, I also want you to know that he can kick some butt if he needs to.

Peter de Sève

ILLUSTRATOR, CHARACTER DESIGNER
THE NEW YORKER MAGAZINE, DISNEY, PIXAR, AND OTHERS

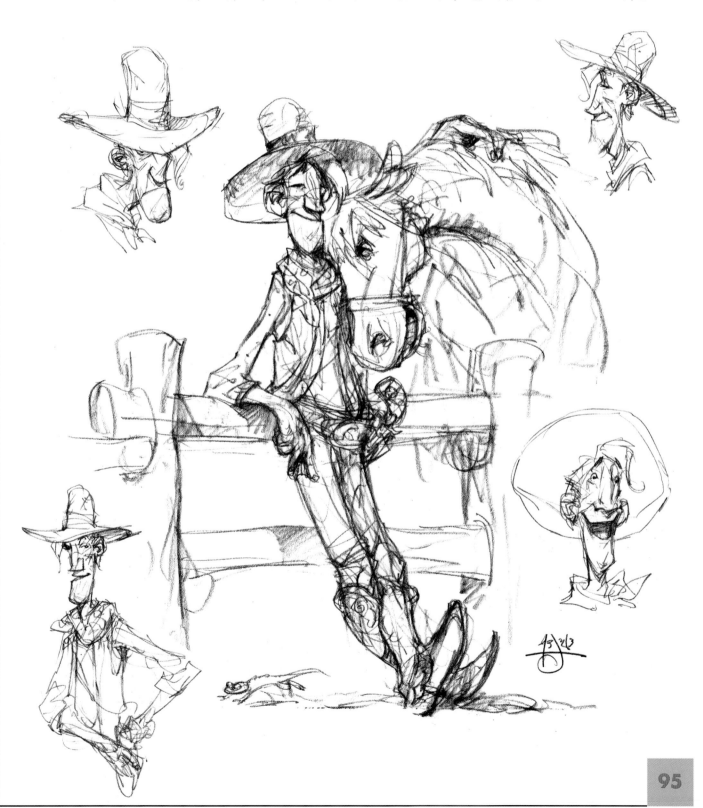

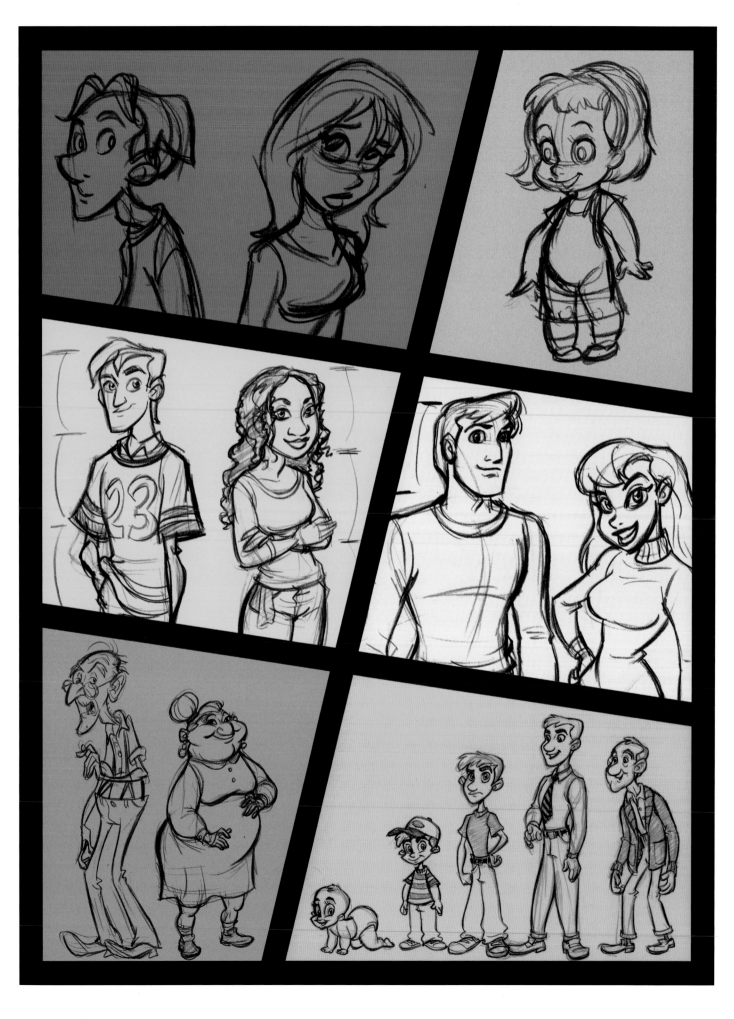

CHAPTER SIX

LOOK YOUR AGE!

A chill descends upon even the most talented designers when a client requests that a character be a specific age. It's hard enough to address the concerns we've covered in previous chapters, such as design, appeal, shape, and poses. But a drawing really becomes challenging when you throw in anxiety about the client's reaction to it. The client may look at the design you love and simply dismiss it with, "He doesn't look old enough."

There are three major elements to remember when designing a character to look a certain age: size, angularity, and amount of detail. Your character will look younger or older depending on the size relationships you establish between different parts of the body, how round or angular you draw those shapes, and how much detail, or line work, you put into them.

In this chapter we will look at some of the details that will vary with the ages of your characters. Take special note that as the character ages, the eyes get smaller but the feet, nose, and ears keep growing.

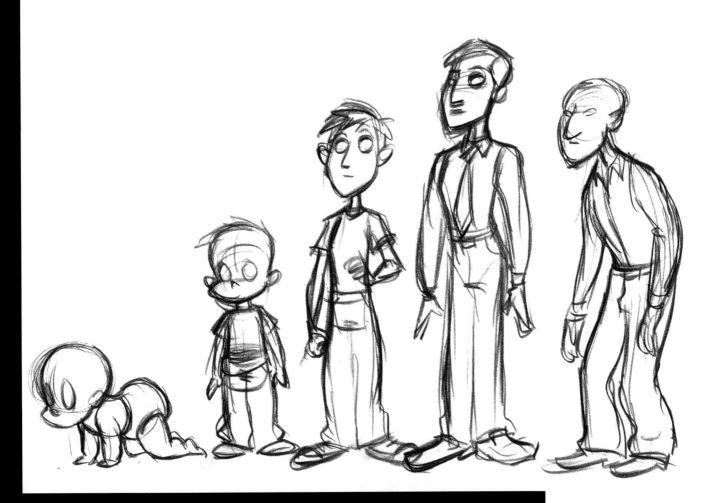

BABIES

Think rounded. Whether you are drawing realistically or in cartoon style, your design needs to have curves all over it. That's what a baby is made of. Newborns are tiny and thin but have disproportionately large, round heads; older babies have all that wonderful plumpness. Just as puppies have large feet that they grow into, babies have large heads that their small bodies eventually catch up with. It's best to have as few interior lines as possible in your baby designs, since lines age a character. Think simple, clear, rounded shapes, and you will be more than halfway to creating a design that says "baby."

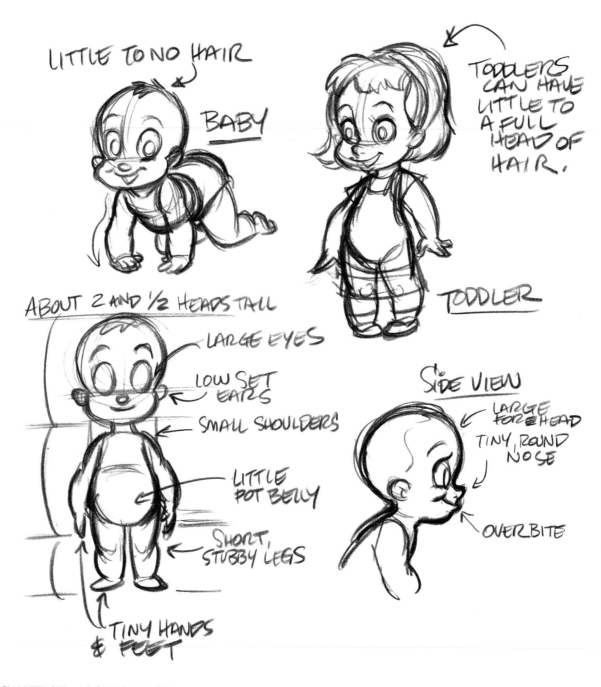

LITTLE TO NO HAIR

BABY

TODDLERS CAN HAVE LITTLE TO A FULL HEAD OF HAIR.

TODDLER

ABOUT 2 AND ½ HEADS TALL

LARGE EYES

LOW SET EARS

SMALL SHOULDERS

LITTLE POT BELLY

SHORT, STUBBY LEGS

TINY HANDS & FEET

SIDE VIEW

LARGE FOREHEAD

TINY, ROUND NOSE

OVERBITE

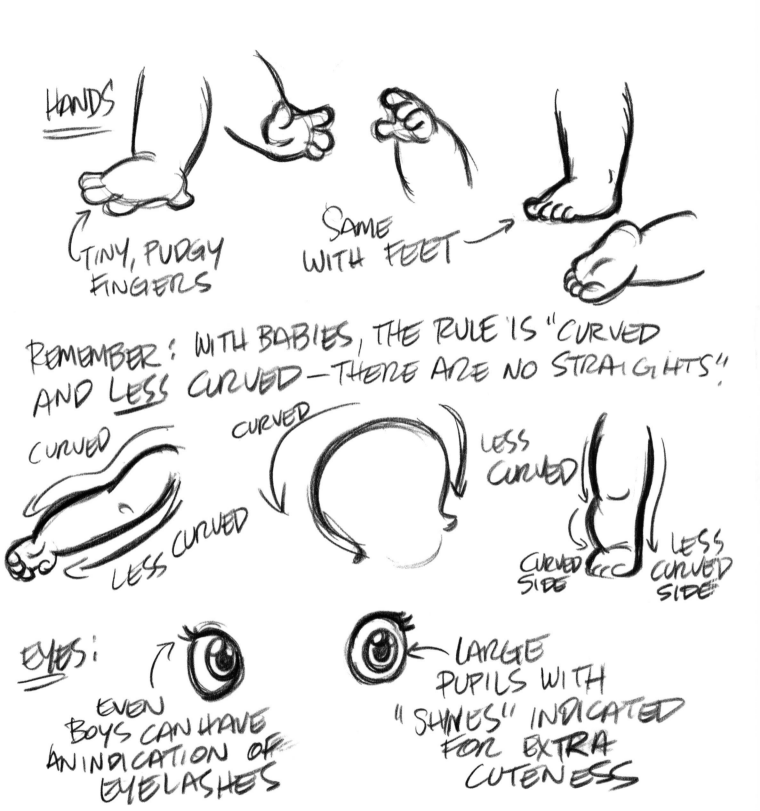

HANDS

TINY, PUDGY FINGERS

SAME WITH FEET

REMEMBER: WITH BABIES, THE RULE IS "CURVED AND LESS CURVED—THERE ARE NO STRAIGHTS!"

CURVED

CURVED

LESS CURVED

LESS CURVED

CURVED SIDE

LESS CURVED SIDE

EYES:

EVEN BOYS CAN HAVE AN INDICATION OF EYELASHES

LARGE PUPILS WITH "SHINES" INDICATED FOR EXTRA CUTENESS

CHILDREN

Children have more straight lines than babies do. The really important element in drawing children is the relationship between the size of the head and the body, a key factor in defining the age of any character.

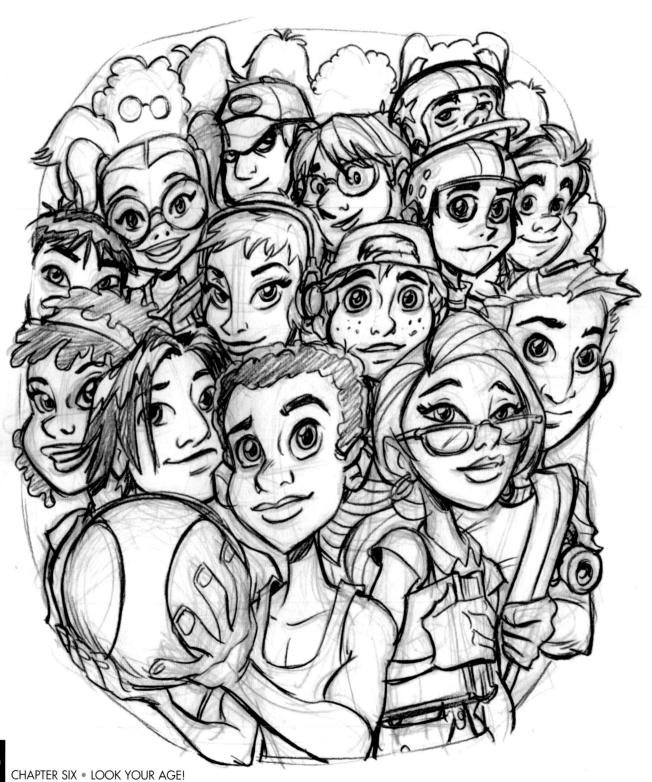

Almost any kind of odd size relationships will work when creating that "in between" look (ages 8 to 12). That's why it's called the awkward age, right?

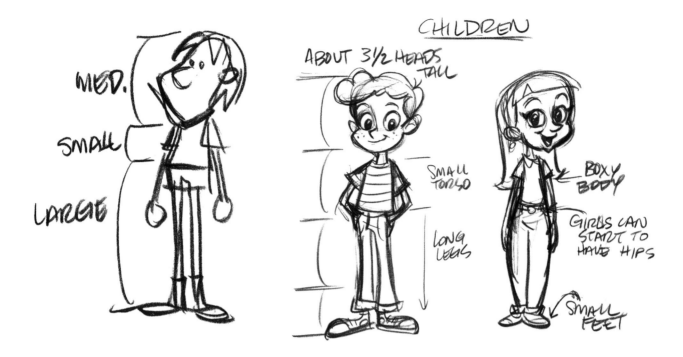

MED.

SMALL

LARGE

CHILDREN

ABOUT 3½ HEADS TALL

SMALL TORSO

LONG LEGS

BOXY BODY

GIRLS CAN START TO HAVE HIPS

SMALL FEET

TEENS

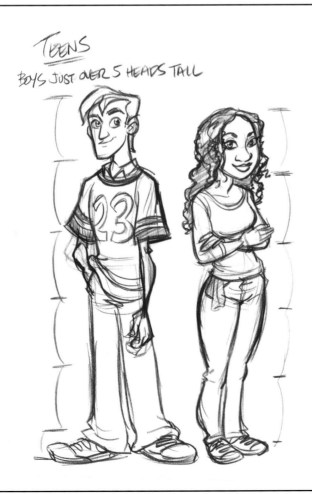

TEENS

BOYS JUST OVER 5 HEADS TALL

Be careful not to draw teens as you would small adults. There are some very discernible differences. For one thing, body shapes among teens vary more than they do in almost any other age group: lumpy, skinny, buff, bent over, straight-backed. Consider, too, all the other variations: glasses, mohawks, shaved heads—the varieties are endless.

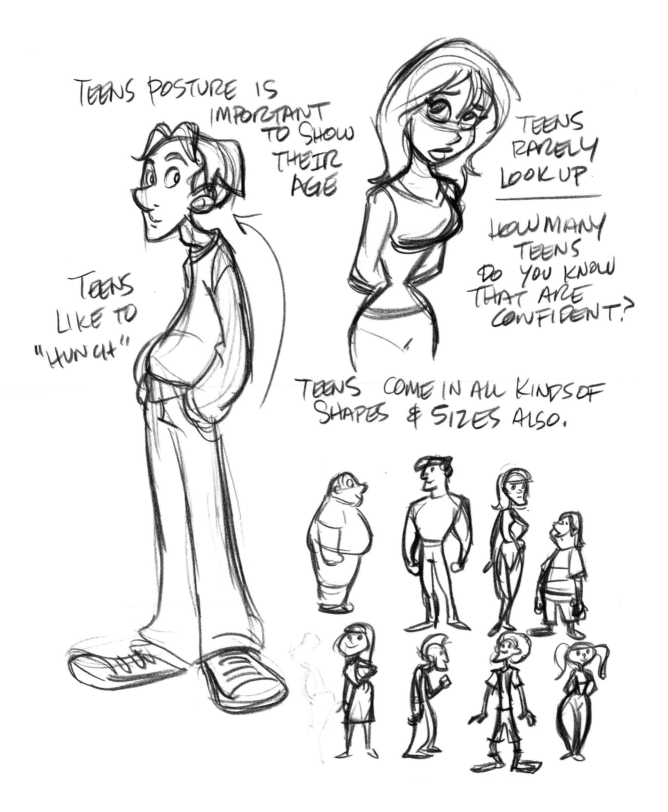

TEENS POSTURE IS IMPORTANT TO SHOW THEIR AGE

TEENS RARELY LOOK UP.

HOW MANY TEENS DO YOU KNOW THAT ARE CONFIDENT?

TEENS LIKE TO "HUNCH"

TEENS COME IN ALL KINDS OF SHAPES & SIZES ALSO.

When you draw teenagers, you'll use a lot of the same design principles you used for drawing kids: large head-to-body relationship, large eyes, rounded shapes, longer legs, bigger ears. You'll just be more subtle when drawing teens—until you get to their extremities. With boys, especially, you will want to make the hands and feet awkwardly large in comparison to the rest of the body.

ADULTS

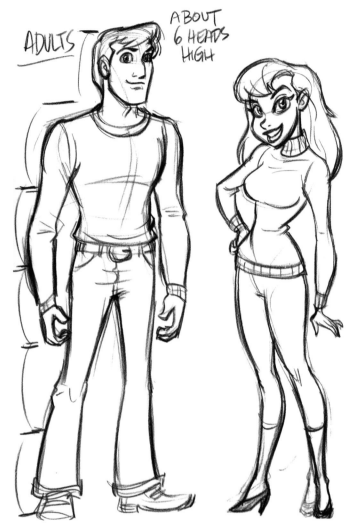

ADULTS

ABOUT 6 HEADS HIGH

Variety reigns, again, but some standard elements will help make an adult look mature: smaller eyes and ears, angular shapes, larger noses on men; "bigger" hair on women.

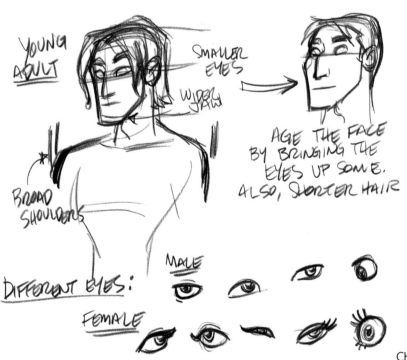

YOUNG ADULT

SMALLER EYES

WIDER JAW

BROAD SHOULDERS

AGE THE FACE BY BRINGING THE EYES UP SOME. ALSO, SHORTER HAIR

DIFFERENT EYES:

MALE

FEMALE

OLDER PEOPLE

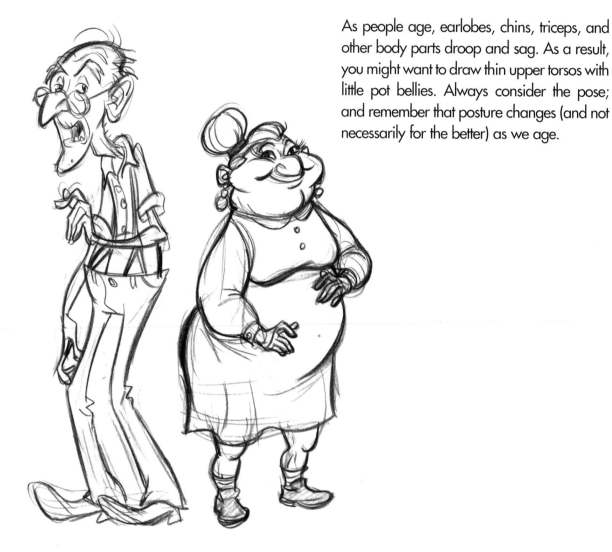

As people age, earlobes, chins, triceps, and other body parts droop and sag. As a result, you might want to draw thin upper torsos with little pot bellies. Always consider the pose; and remember that posture changes (and not necessarily for the better) as we age.

TO GET THAT "OLDER" LOOK:
1) LARGE EARS & NOSE
2) SMALL EYES
3) MORE INTERIOR LINES

Try this on your own: Draw five different versions of a character at different ages, from babyhood to old age. Remember to make your character recognizable as the same person at each age. To make this kind of continuity easier to achieve, you might want to draw a major media character whose face you know well.

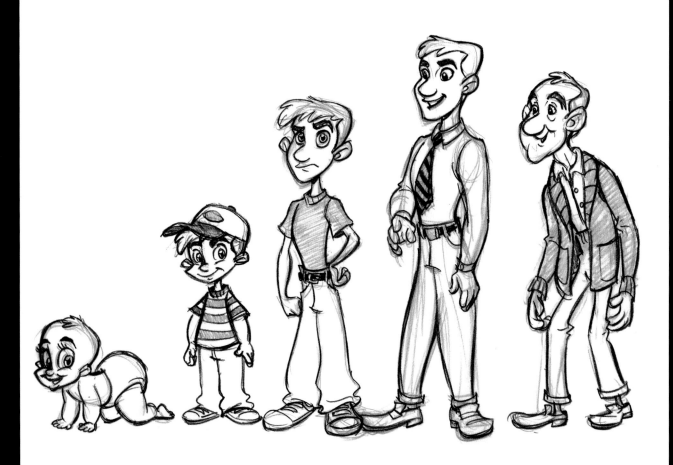

TRYING IT OUT

Mathew Bronleewe and Jeremy Bose are music producers who also create animated shows for kids. They hired our company, Funnypages Productions, to develop characters for a show called *Digg Kids*, about four adopted children who go on adventures with their archaeologist parents. Our assignment was to create the four kids and their nemesis, a villain who always manages to learn what the kids are looking for and find it before they do.

We were given a brief description of each of the characters. We had to create a Caucasian boy about 12 to 14 years old, an Asian girl just a little younger than him, and two African-American twins between 6 and 8 years of age. So, the challenge wasn't just to create kids who looked a specific age, but were also of different races. Of course, we also wanted to render these kids in a fun, edgy style.

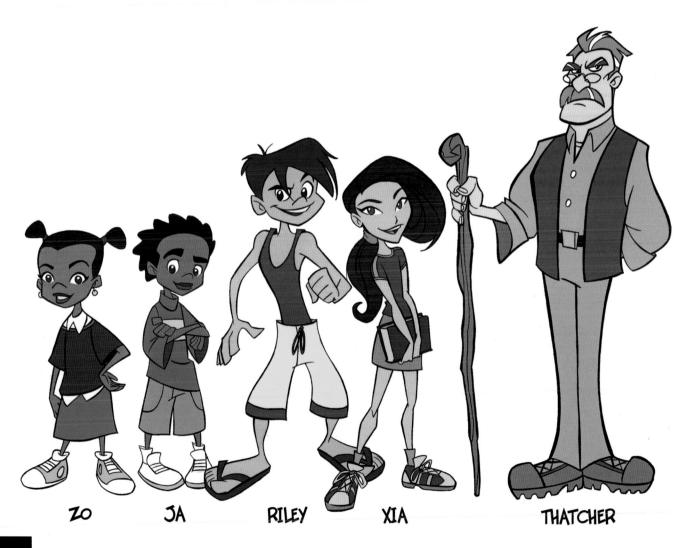

ZO JA RILEY XIA THATCHER

Now that you have a rough design for Polly, try creating a design of her mother, the town beautician. The challenge here will be to create a character who resembles Polly but is older. Remember, Polly and her mom need to look like they're related, but not like they're sisters.

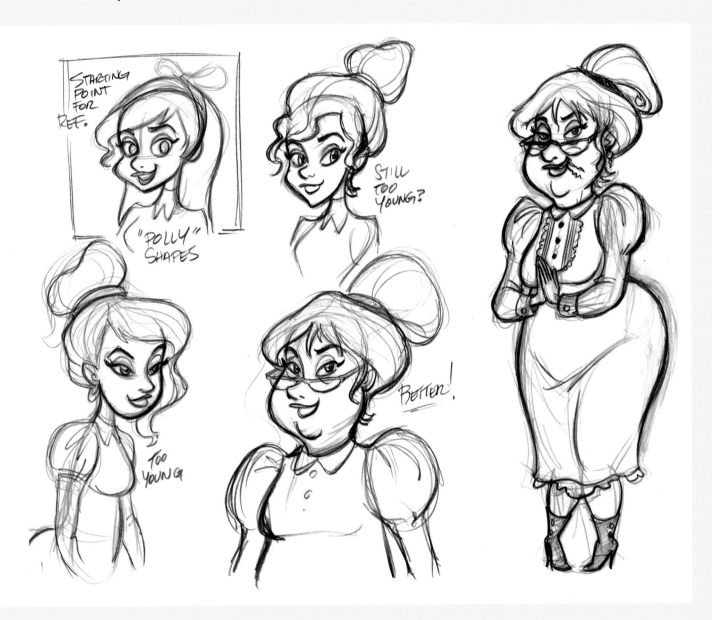

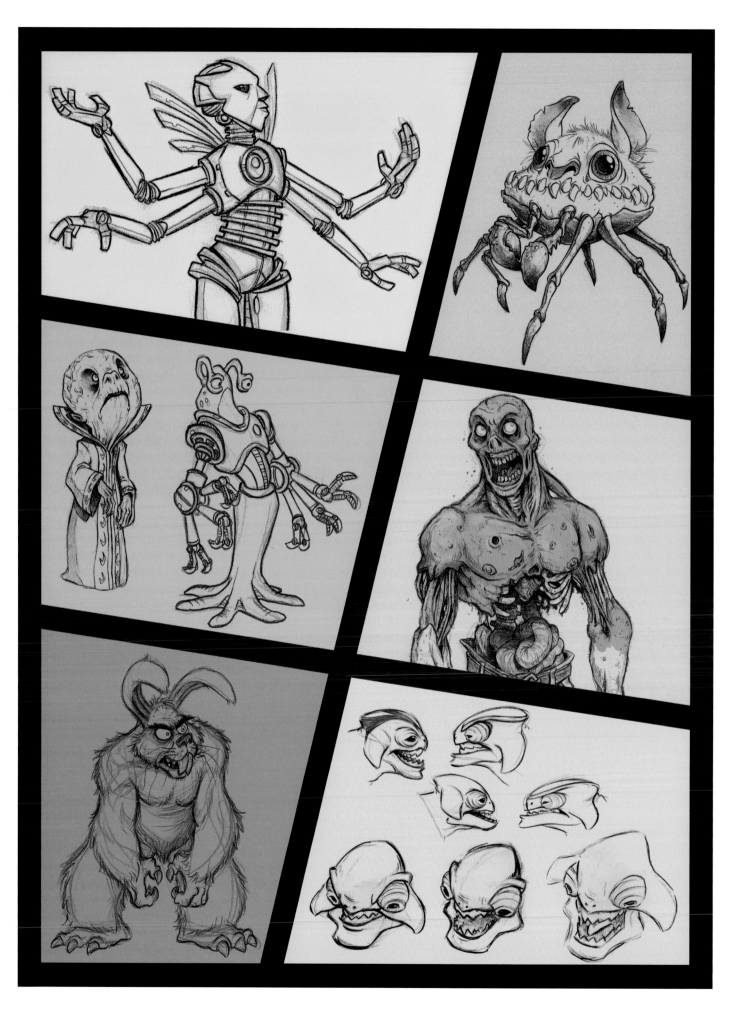

CHAPTER SEVEN

MONSTER, CREATURES, AND PERSONALITIES?

This chapter is written and illustrated by Rob Corley, my good friend and business partner in our company, Funnypages Productions. Like me, Rob is a former Disney animator, and he has worked on many feature films and other projects. I tapped him for this chapter because whenever time seems to be dragging (as it does when we are in meetings), he is constantly doodling fun, odd, and sometimes creepy characters. This is an ability I don't have, but he makes it look easy. I hope you enjoy this little look into Rob's mind!

Growing up, I always had (and still have) a fascination with monsters and creatures. I think it all started when I first saw the Cyclops in *The Seventh Voyage of Sinbad*. That monster left an impression on me that I will never shake. I liked the Cyclops so much that I actually felt sorry for him when Sinbad's men gave him the old "red hot poker to the eye" trick just to escape.

What I didn't know at that time, but realize now, is that Ray Harryhausen, the man who created and animated the Cyclops and every other Sinbad monster to date, was able not only to design a cool-looking creature, but also to give it some personality . . . okay, not a very nice one, but it had character. The same was true with Boris Karloff in *Frankenstein*. A sympathetic monster who wasn't exactly pleasing to the eye and only wanted to be loved . . . hmmm, sounds like my high school prom. What I slowly began to realize over the years is that what really made so many of these creatures endearing to me as an artist was their "design," or how they looked. So, let's take a look at the overall thought process of designing monsters and creatures, with a few zombies and wretched humanoid-style characters thrown in along the way.

- CREATURE QUESTIONS ● ANATOMY 101 ● SHAKE AND BAKE
- LET'S GIVE 'EM A HAND ● CYBORG A-GO-GO ● I'M NOT DEAD YET
- EXPLORING A DESIGN ● MISCELLANEOUS FUN STUFF

CREATURE QUESTIONS

Approaching the design of a new monster or creature can be both exciting and mind-boggling. Exciting because the sky's the limit, and mind-boggling because, well, the sky's the limit. One of the best things I learned while working as an animator for Disney was character development. Before designing, think about a character. Who is this character? Is the creature animal, vegetable, mineral, or all of the above? What are its strengths, its limitations? What is its objective? Does it, or can it, communicate? Is it from the future? Where does it dwell? Is it a beast of burden or a supreme intelligence? How would it react in different situations? What are its strengths and weaknesses? Is the character proud or shy? The list could go on, but these types of questions will help you hone in on what will or will not work in your drawings. They will bring life to your characters, who will begin to develop personalities—so much so that if a certain situation comes up in the story, you'll know exactly how the characters would respond. And remember, a client usually has his or her own opinions about the creature they would like to see emerge from your designs. Listen to the clients: You may not always agree, but they do pay the bills.

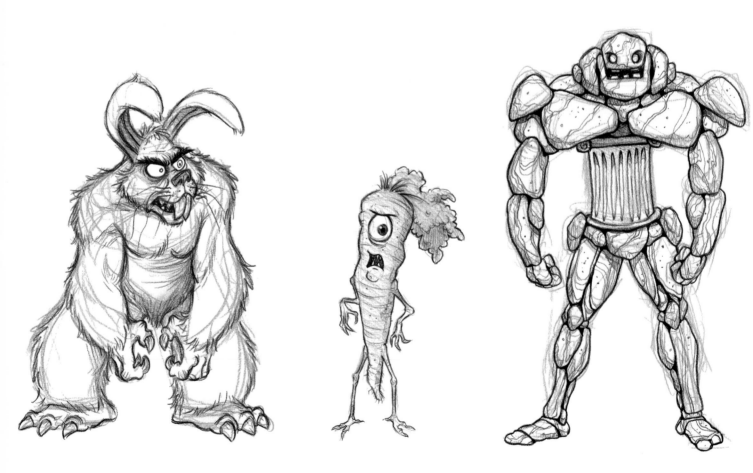

ANATOMY 101

Is anatomy an issue when designing monsters? Does it really matter if I understand how it all works? Yep. Having a working knowledge of artistic anatomy will definitely improve your drawings. You're not learning to become a surgeon, just a better artist, but nothing will kill a design quicker than a poor drawing that's anatomically "off."

You can never have enough reference materials around you when you sit down to design a character. I use *Artistic Anatomy* by Dr. Paul Richer, published by Watson-Guptill. There are a lot of other great books out there that will help you get a good grasp on how things look and how body parts connect or relate to one another. The works of other artists I admire have also been a great and constant inspiration for me in generating ideas.

It's all about the basics: Memorize the basic bone and muscle systems and how they relate to one another. It will help you understand how your character is built from the inside out.

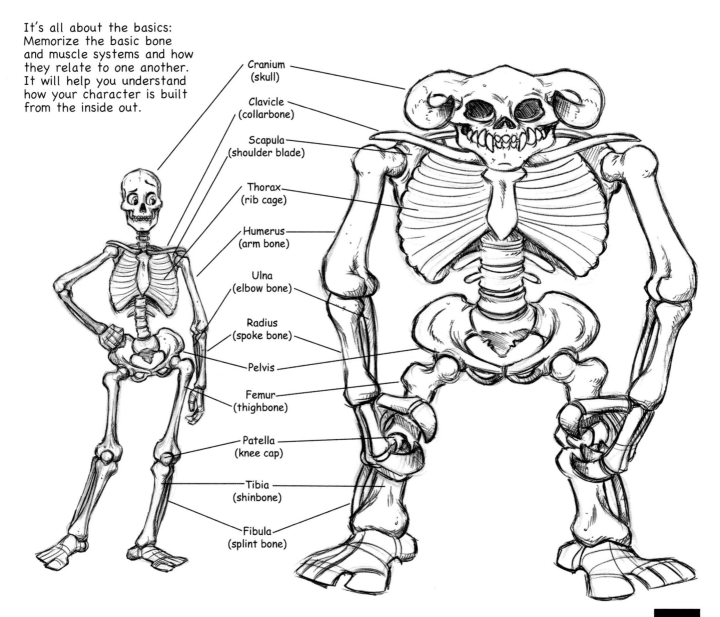

Cranium (skull)

Clavicle (collarbone)

Scapula (shoulder blade)

Thorax (rib cage)

Humerus (arm bone)

Ulna (elbow bone)

Radius (spoke bone)

Pelvis

Femur (thighbone)

Patella (knee cap)

Tibia (shinbone)

Fibula (splint bone)

SHAKE AND BAKE

Our author, Tom Bancroft, says he got the idea for the character of Mushu in Disney's *Mulan* from several different animals. Mushu has cow ears, catfish whiskers for a moustache, the body of a snake, the feet of a chicken, and the tail of a lizard. Another incredible artist who has mastered this mix-and-match technique is Terryl Whitlatch, who did the development designs for many of the animal characters in the 2003 Disney film *Brother Bear*. Want another great reference book for your library? Take a look at Terryl's illustrations in *The Wildlife of Star Wars*, published by Chronicle Books.

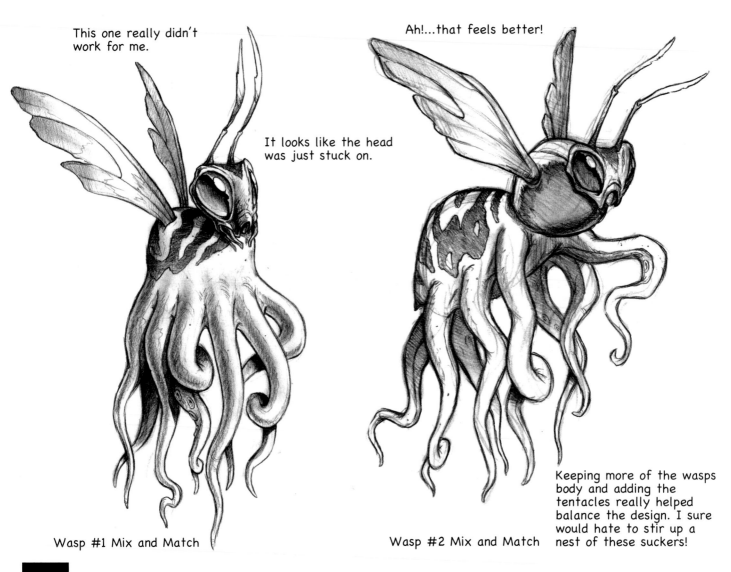

This one really didn't work for me.

It looks like the head was just stuck on.

Ah!...that feels better!

Keeping more of the wasps body and adding the tentacles really helped balance the design. I sure would hate to stir up a nest of these suckers!

Wasp #1 Mix and Match

Wasp #2 Mix and Match

Crab Mix and Match

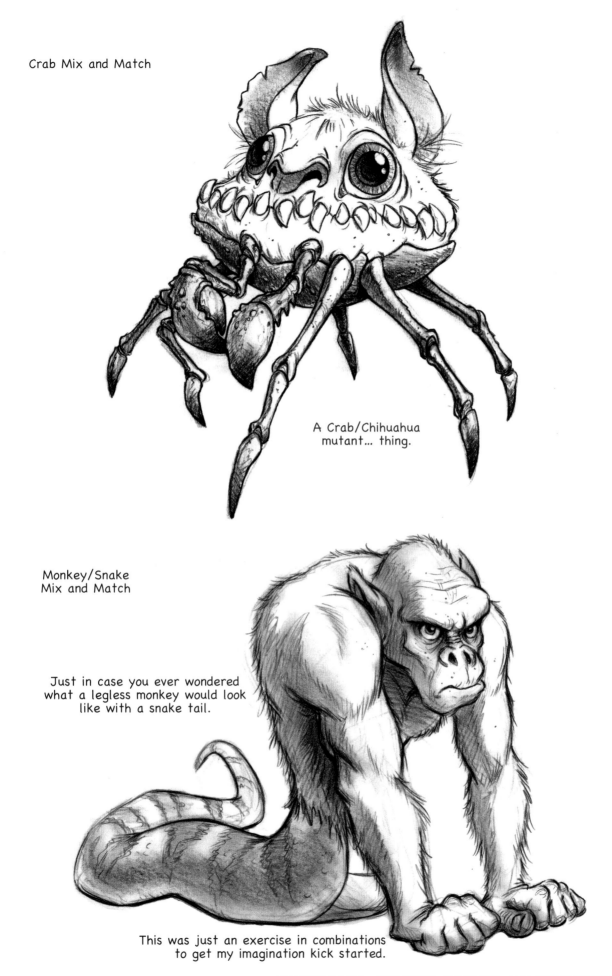

A Crab/Chihuahua
mutant... thing.

Monkey/Snake
Mix and Match

Just in case you ever wondered
what a legless monkey would look
like with a snake tail.

This was just an exercise in combinations
to get my imagination kick started.

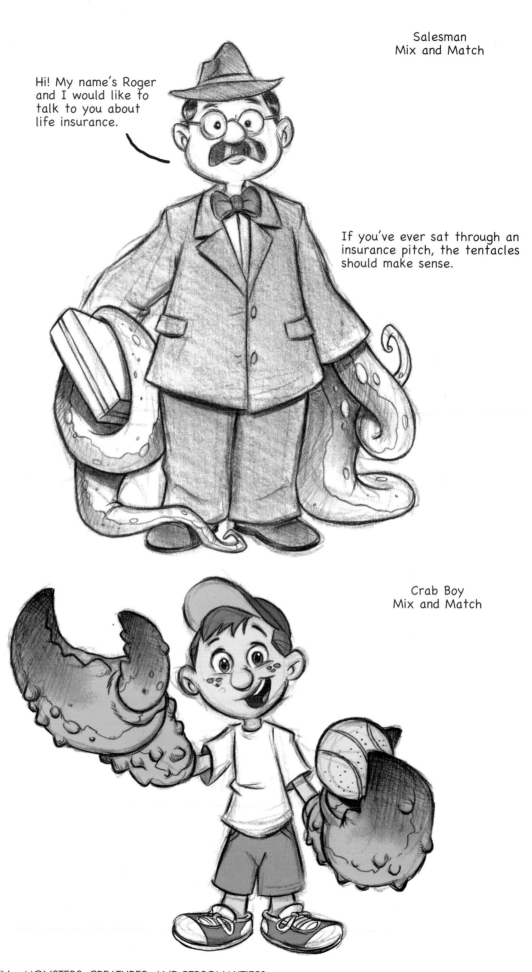

Hi! My name's Roger and I would like to talk to you about life insurance.

If you've ever sat through an insurance pitch, the tentacles should make sense.

Crab Boy
Mix and Match

LETS GIVE 'EM A HAND

Hands are probably one of my favorite things to draw, and the creepier and odder-looking the better. As you design hands, think of how they will work with your overall design. Will your creature be using them to pick daisies or fillet the flesh from some unsuspecting victim? Try weird variations; you never know what you'll come up with.

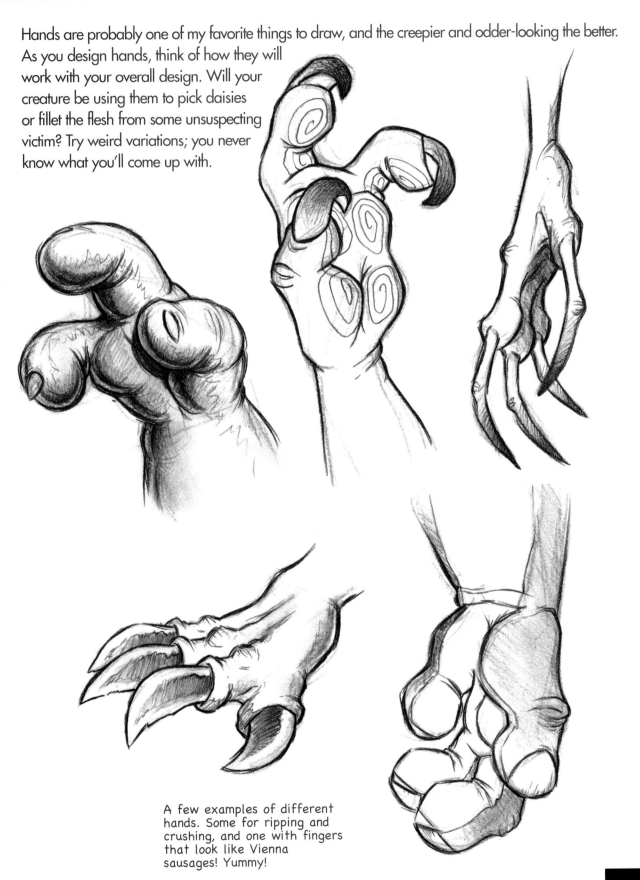

A few examples of different hands. Some for ripping and crushing, and one with fingers that look like Vienna sausages! Yummy!

CYBORG A-GO-GO

Machines can be a great inspiration for monster designs. You can go with the straight, menacing robot type, or better yet, if you're looking for a creepier design, you can combine metal parts and gears with flesh and tendon. Arnold from the *Terminator* movie series is a perfect example of this sort of combination. Combining human or animal tissue with some sharp, dirty yard implement will give you a dang awful-looking creation, too.

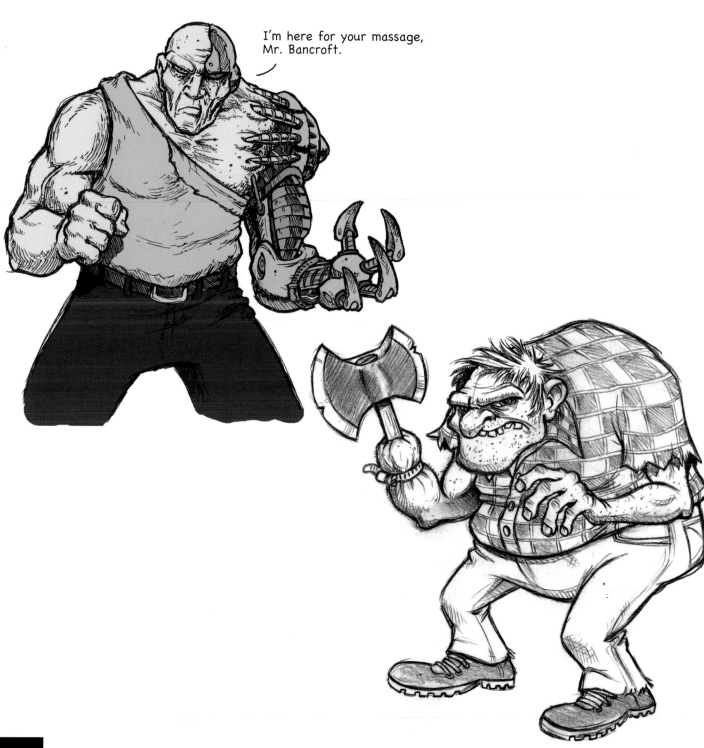

I'm here for your massage, Mr. Bancroft.

I'M NOT DEAD YET

No chapter on monsters and creatures is complete without a disgusting zombie drawing. Zombies, or, more affectionately, "the living dead," can be fun to draw. There really aren't many rules when it comes to drawing these creeps, and usually a little imagination and a strong stomach will work wonders. One way to find out if your design is working is to show it to someone. If they cringe, you did alright. If they scream, not too shabby. And if they throw up, ya done real good!

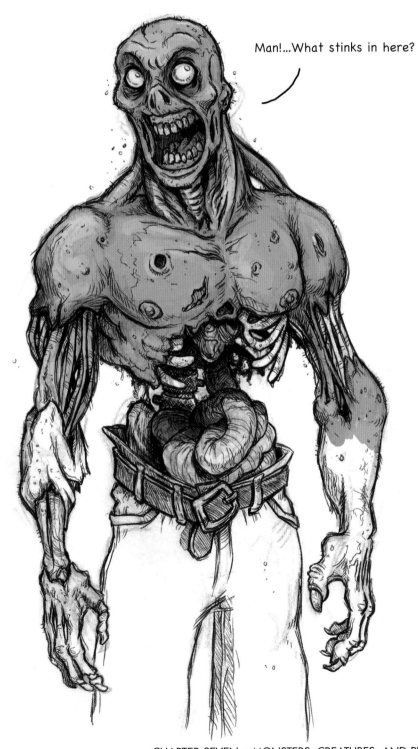

Man!...What stinks in here?

EXPLORING A DESIGN

When I sit down to begin designing, very rarely, and I mean *very* rarely, do I keep the first thing that I put onto the page. I really enjoy drawing, and this is my chance to do a lot of it as I break down a character's overall look by playing around with the proportions. I also like to think about things that will make each character unique. I try to avoid the cliché as much as possible and push myself to think outside the box. I've included a few examples of a character that I will begin designing and that hopefully, in the end, will evolve into something that looks halfway decent. For this example, I chose one of my favorite creatures . . . Bigfoot!

#1

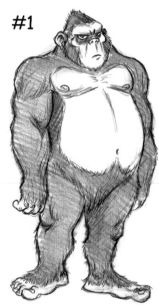

Too boring! Your average guy in a gorilla suit design.

#2

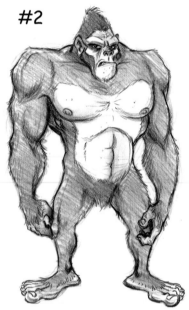

A little more interesting. I pushed the shoulders out and thinned his legs down. Still needs work.

#3

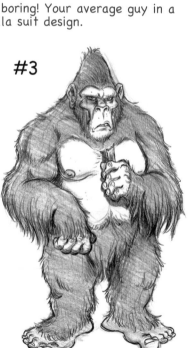

Definitely more gorilla like. I made his hair longer and went for the plumper, well fed look.

#4

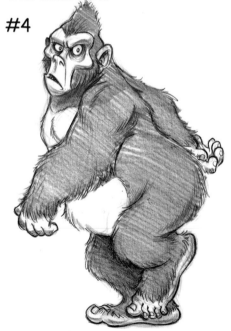

Ok...now I'm liking it! More caricatured features in a classic Bigfoot pose. This is probably my favorite.

#5

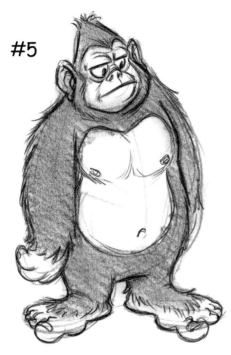

A more cartoony, cuter version.

#6

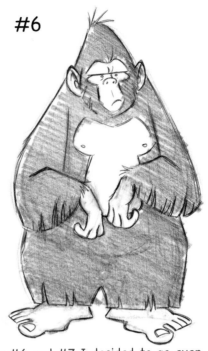

On #6 and #7 I decided to go even further and streamlined the design. Saturday morning cartoon style.

#7

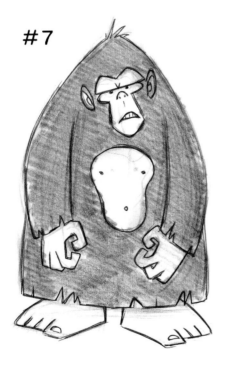

I still don't feel like I went as far as I could have with this particular design. There are still a million other combinations to explore. I could have done a few with really hugh feet and a tiny head. Since most of my examples were on the heavy side, another set of designs can be more thin and gangly looking. This is the fun part of designing, the part I enjoy most.

MISCELLANEOUS FUN STUFF

I wanted to end this chapter with a few drawings that showed some variety in style. It's always healthy and—golly!—just plain fun to flex those artistic muscles from time to time. Some of your designs will obviously work better than others, and you'll always throw away more drawings than you keep, but the goal is to explore the possibilities by breaking out of your comfort zone and trying something different.

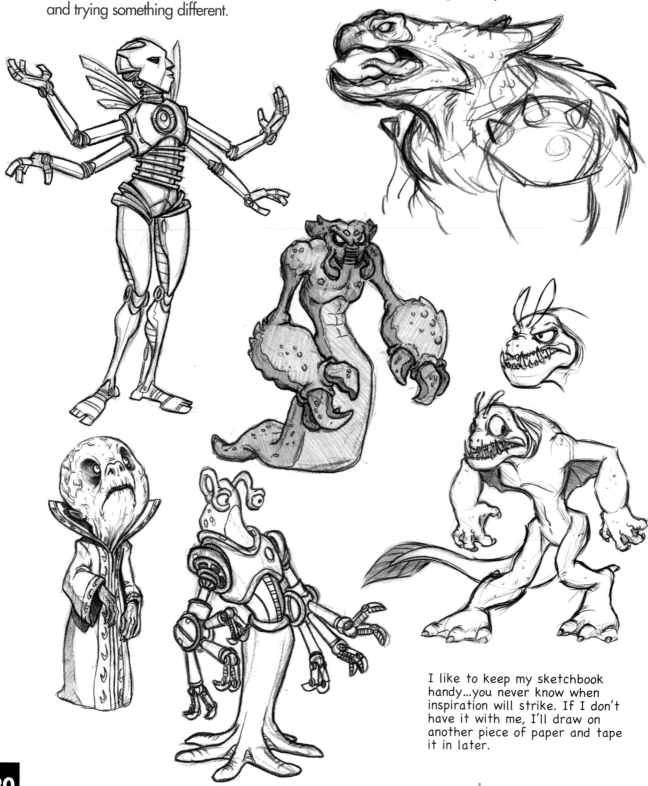

I like to keep my sketchbook handy...you never know when inspiration will strike. If I don't have it with me, I'll draw on another piece of paper and tape it in later.

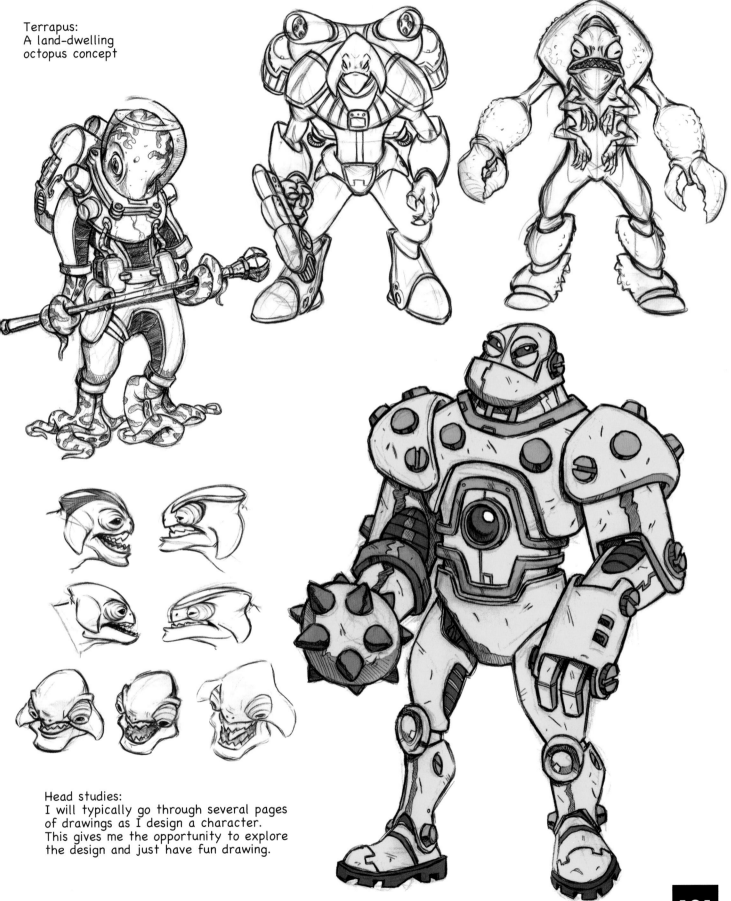

Terrapus:
A land-dwelling
octopus concept

Head studies:
I will typically go through several pages
of drawings as I design a character.
This gives me the opportunity to explore
the design and just have fun drawing.

CREATOR PROFILE/COMIC BOOKS

J. Scott Campbell was born in East Tawas, Michigan, in 1973. Growing up, Scott always had a deep passion for drawing and art, and even began pulling in a good amount of income from it while still in high school. In 1993, he moved to San Diego and broke into the world of comic-book illustration. Campbell quickly rocketed to fame with his very first book, *Gen 13*, and gained a reputation for illustrating some of the most attractive women in the business. His dynamic storytelling and playfully animated style lent themselves perfectly to his follow-up project, the smash hit *Danger Girl*. Campbell currently resides in Colorado with his wife, Keyke, and his baby daughter, Dawn. His latest project is the 2005 release *Wildsiderz*.

HIS THOUGHTS ON DILLON

The design of Dillon seemed to flow quite naturally. I didn't find myself struggling too much. That certainly isn't always the case when designing new characters, but it helped that the description provided was so detailed. For instance, the character is described as "tall and thin." That immediately helped me to avoid going down any dead-end paths, possibly exploring shorter and/or pudgier versions of Dillon. Also, the idea of these old baggy clothes hanging off his wiry, sticklike body like old outfits on a clothes hanger seemed like a great visual. I also wanted his face to be thinned out, but not too much. After all, he was still supposed to come across as boyish... at least in my mind he was. I gave him a slightly larger tip of the nose and a slight upper-lip overbite, too. I think I was able to convey a bit of the late-teen gawkiness that so many young males have, while hopefully still making it seem possible that an attractive girl like Polly could fall for him. I also gave him heavy eyelids, thus indicating his apparent laziness and lack of drive.

I'm a comic-book artist, but I've always felt a sort of artistic kinship with animators. Because of my intense love of cartoons and animation, that influence has always found its way into my artwork. That sense of exaggeration is definitely present here in Dillon. I had a lot of fun elongating his limbs and fingers, and I think it makes for an even more appealing design. I also made sure to give him a slumpy posture, almost a ? shape to his spine. When he draws his gun, I imagined it would be like a rubber band recoiling.

J. Scott Campbell

comic book artist, Gen 13, Dancer Girl, Wildsiderz

I happen to love Westerns, so I had several reference books with lots of firearms and hats to look at. I also took a look at several movies that I have on DVD. *Young Guns, Back to the Future III*, and *The Quick and the Dead* were the most helpful. Leonardo DiCaprio's character in *The Quick and the Dead* was an especially good point of reference for me. I'll often look at movies for this sort of thing. Films will give you not just the look of something, but the movement, the feel, the attitude. I find more and more often that my growing collection of DVDs is invaluable to my artwork.

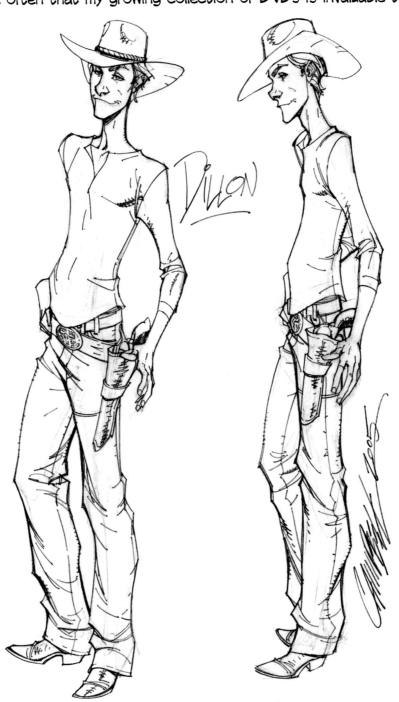

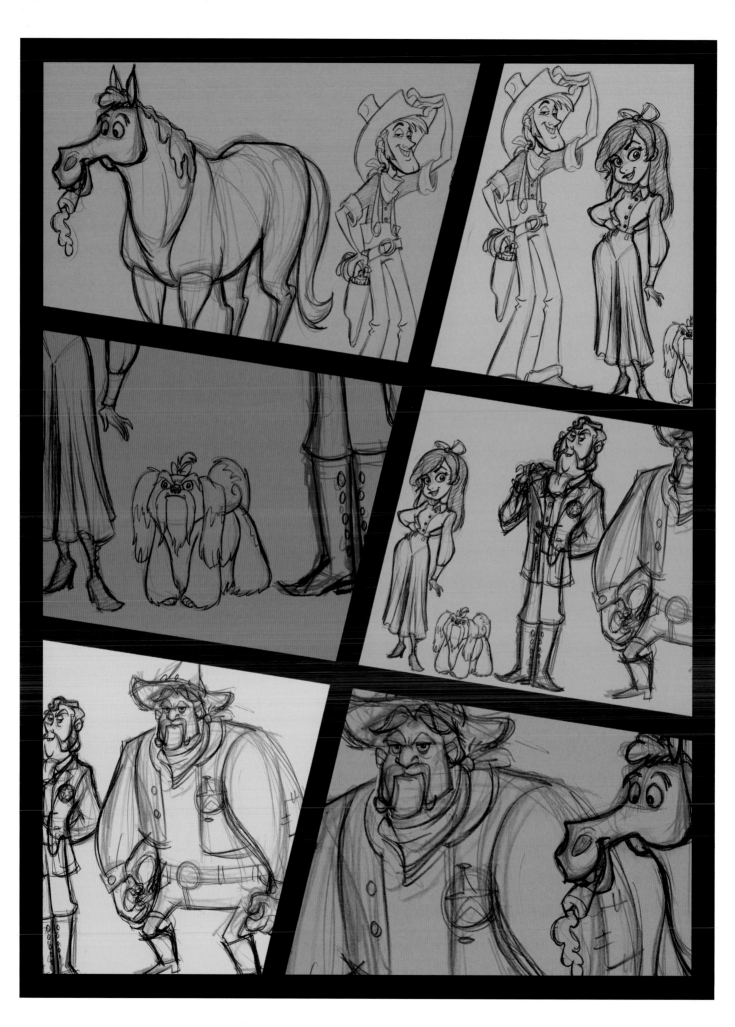

GROUPINGS, OR CREATING THE CAST

You've heard the expression "No man is an island," right? Well, this applies to the characters you design. They don't exist in a void. They are part of a cast, and they need to look like they belong with one another—that is, they need to share certain design elements.

- VARIETY IS THE SPICE OF LIFE
- IT TAKES TWO

VARIETY IS THE SPICE OF LIFE

Let's look at a couple of rough designs for a few characters in my imaginary movie and see how they work together.

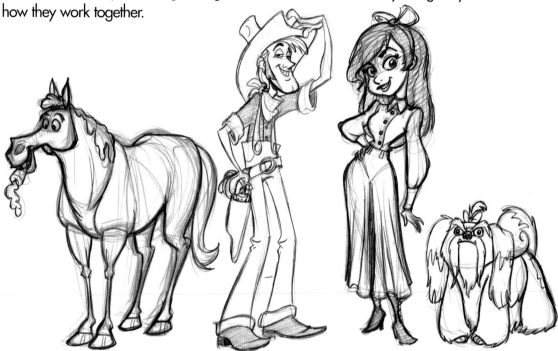

The first thing I notice is that the sizing is even and really doesn't make much sense. Dillon is the hero, and with an eye to his youthful, coltish personality, I've chosen to make him as tall as possible. Polly should be a little shorter than Dillon. This way, when we get to the part of the story where she is captured and Dillon needs to come to her aid, she will look more vulnerable and in need of help. As you can see, the plot can help you determine the size relationships between your characters.

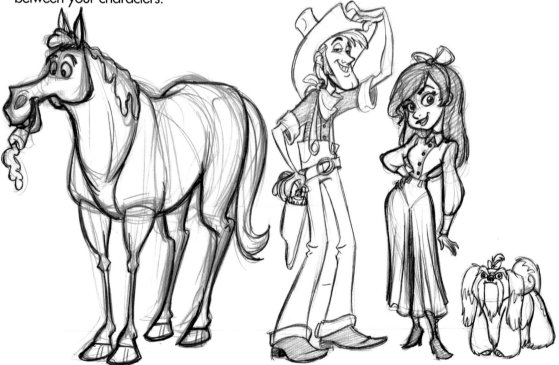

I drew up some rough designs for the villains, Sheriff Brent and his henchman, Grit. These are the first couple of drawings depicting Brent

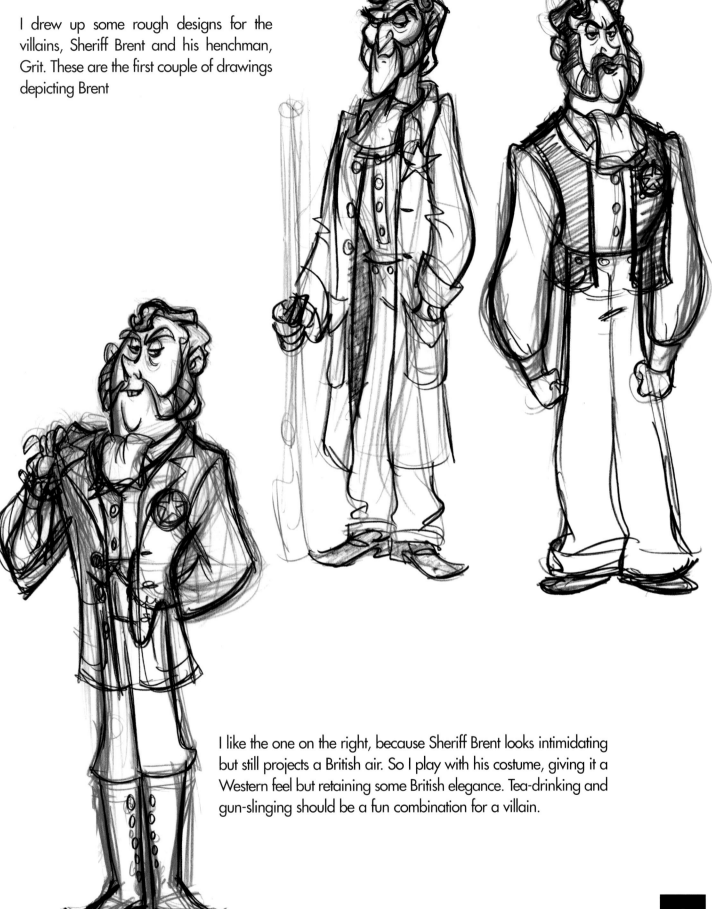

I like the one on the right, because Sheriff Brent looks intimidating but still projects a British air. So I play with his costume, giving it a Western feel but retaining some British elegance. Tea-drinking and gun-slinging should be a fun combination for a villain.

I wanted the design for Grit, the hulking deputy, to say "big." I also wanted him to look not-so-smart. By using a small head atop a big body, I show both aspects of this lug.

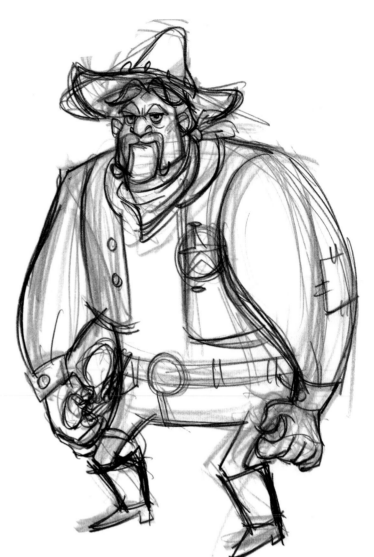

Now I combine these rough designs to show the good guys with the bad guys. A character-size-relationship lineup like this allows you to look beyond individual characters and see the entire cast.

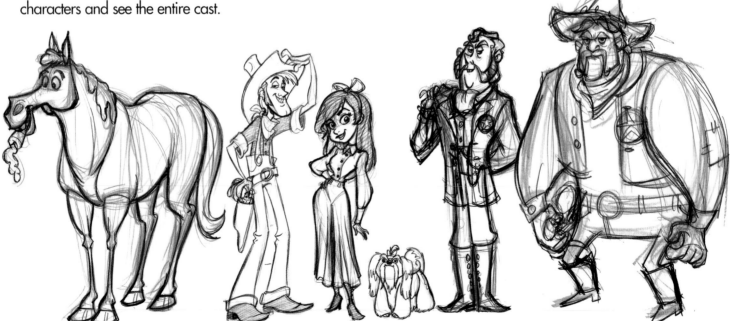

Now, compare the original shape lineup we came up with early in the process of designing the movie (see page 39) with what we have now. Pretty close? This comparison may inspire you to work with these shapes a little more. If you prefer some of the elements of the drawings we did originally, go ahead and use them here.

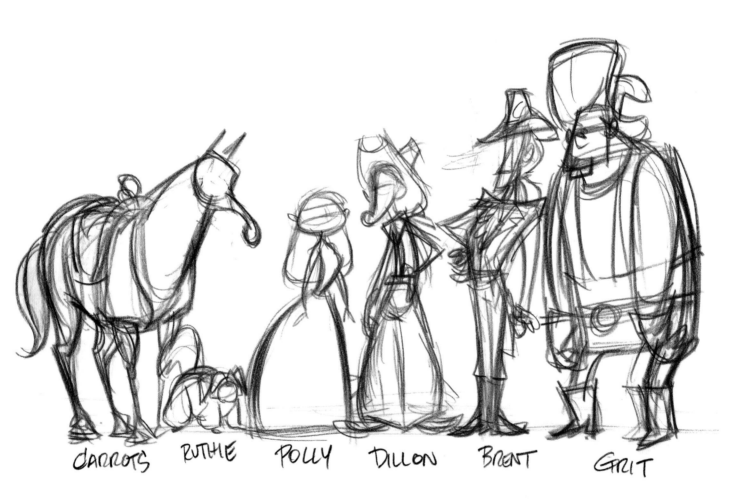

Here's a character lineup I did for a novel about pirates. Can you tell who the lead character is? Think about clues you can get from size relationships; oftentimes the smallest character is the hero, because we naturally root for the little guy (or gal). Can you tell which character is probably the villain? These characters are all rough and rowdy, but the more angular or wider physiques may give you clues as to who the bad guys are.

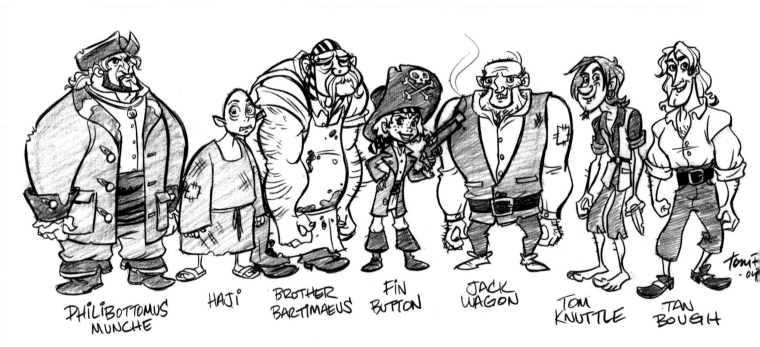

PHILIBOTTOMUS MUNCHE

HAJI

BROTHER BARTIMAEUS

FIN BUTTON

JACK WAGON

TOM KNUTTLE

TAN BOUGH

It can be hard to animate a scene in which a princess talks with a frog friend for long periods of time. The trick is to capture lots of facial expressions, and that requires close-ups—hard to do when the discrepancy in size is so great. One answer is to have the smaller sidekick sit on, perch on, or hang from the larger character's costume. This trick of the trade will enable you to get the characters' heads close together—so they can interact, but without you having to show them in a full shot all the time.

IT TAKES TWO

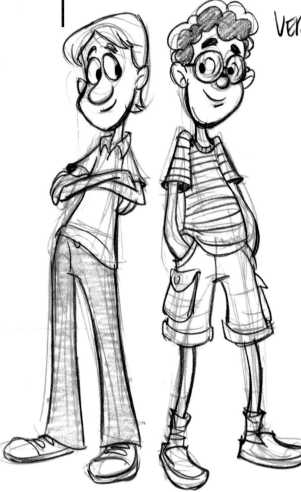

VER. A

TOO SIMILIAR
IN SHAPE & SIZE

Couples, buddies, heroes and their nemeses, bad guys and sidekicks, all share one thing: They need to look good together. One of the key elements in designing two characters who will interact as a team is contrast—between sizes, body shapes, and personalities. Here's a pair who look pretty much the same.

Here are a few ways to vary the design.

VER. B

SIZE
VARIANCE
BETWEEN
CHARACTERS

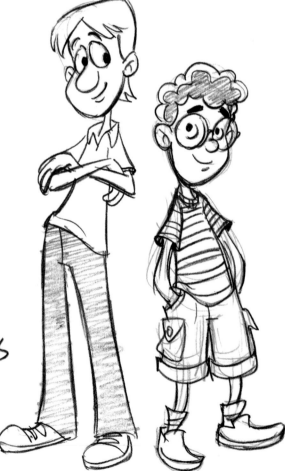

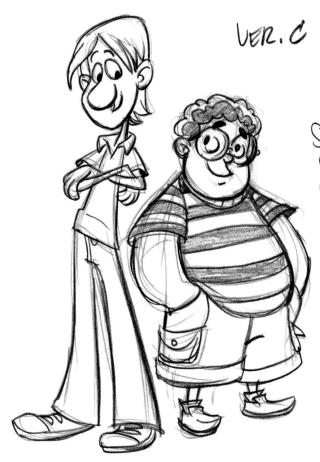

VER. C

SIZE &
SHAPE
VARIANCE

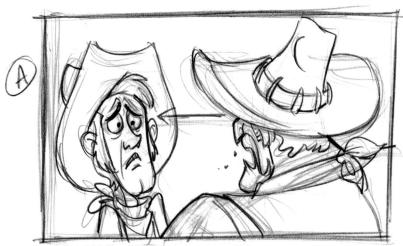

A JUST OKAY

Now, look at these two ways to handle a hero and a villain. Notice how dull the image is when the characters are the same size. Then notice how much more dynamic the image is when I contrast the size of the characters—the hero looks small and overmatched.

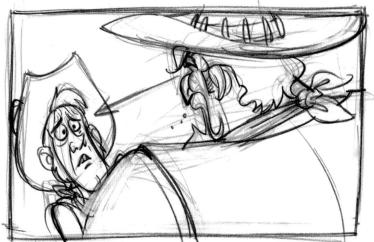

B BETTER!

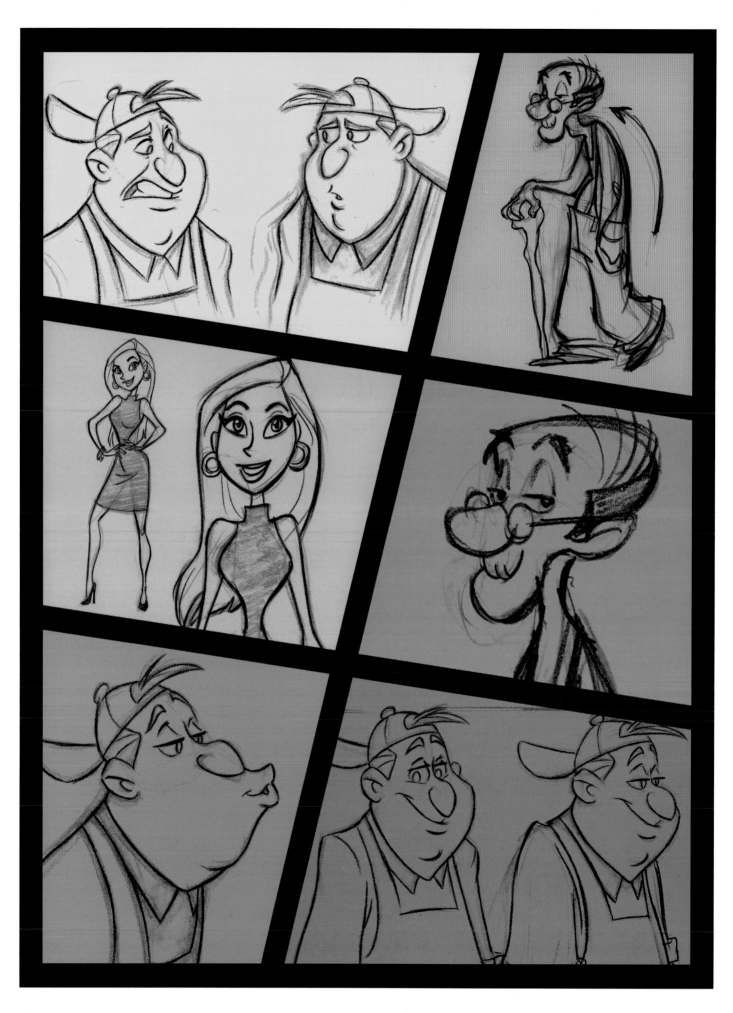

CHAPTER NINE

PUTTING IT ALL TOGETHER: POSE, COLOR, AND STYLE

Now we're getting down to the subtle touches that can make or break a drawing. What poses do your characters strike, and what does this say about them and the story line? What do the colors you use say about your characters? And how do you add a sense of style to your drawings?

Before you put pen to paper, think three-quarter front view. That's the angle that usually works best in creating characters who have dimension and attitude. Characters you create from this angle will be much more emotive than those you portray in a straight-on front shot, just standing there staring back at you with their arms at their sides.

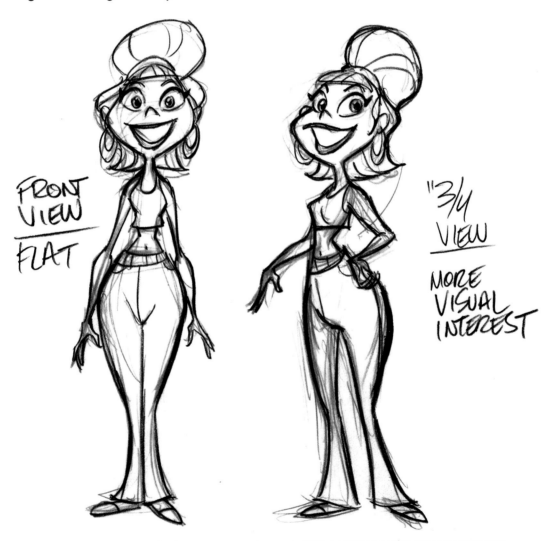

FRONT VIEW FLAT

"3/4 VIEW

MORE VISUAL INTEREST

● POSE AND EMOTE! ● THE EYES HAVE IT ● GO WITH THE FLOW
● COLOR PERSONALITY ● ROUNDING OUT THE CAST ● STYLE

POSE AND EMOTE!

Poses create attitude. Begin by imagining the poses your character will need to strike in the story to convey various emotions, personality attributes, age, and other characteristics. If you are designing an old man, for instance, you might want him to be a bit slumped, rather than standing straight. This pose immediately suggests advanced age.

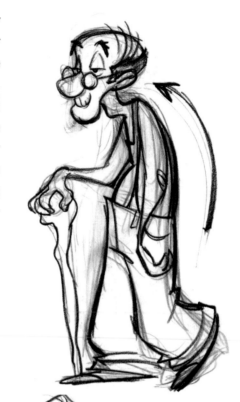
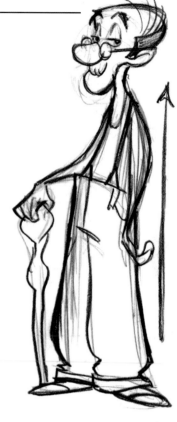

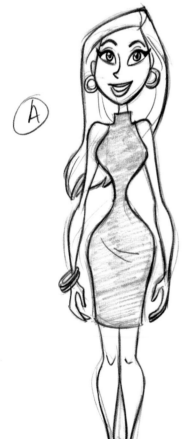

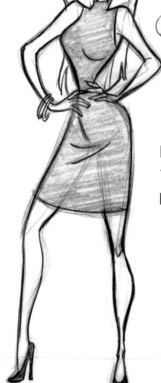

Pose also gives your character that indefinable "right" feeling. Case in point: Which one of these poses do you find more appealing?

"GUS" TURNAROUND SHEET

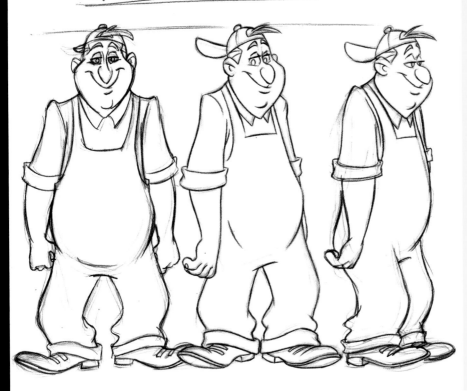

In the animation world, we create what are called "model sheets." These are simply pages that show a character in various poses, with different expressions, and seen from various angles. Likewise, a "turnaround sheet" shows the character in a plain pose from all different views, so the artist knows what the character and his/her costumes look like from all angles. An "expressions sheet" shows how a character's face changes with each change in emotion or mood.

"GUS" ROUGH EXPRESSIONS

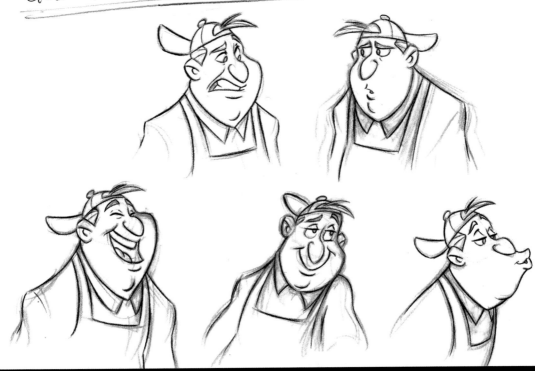

THE EYES HAVE IT

When I was starting out, my mentor used to tell me, "Make sure the eyes don't wobble or move around the face, because you'll notice the eyes before anything else." The lesson here is, it's important that you make the eyes look good. Begin with round eyes, no matter the angle in which you've placed your characters. You'll find it easier to place the eyes on the face when they are round. Then, once the eyes are in the right position, vary the eye shapes as you wish.

There are three main elements to creating stronger expressions in the eyes.

• **EYEBROWS** affect the tops of the eyes, as they compress and stretch the eye shape.

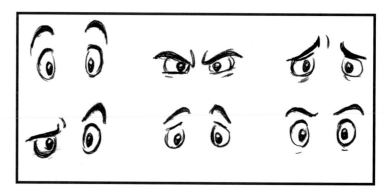

• **BOTTOM LIDS AND CHEEKS** often work together, since the upward compression of the cheek (when the mouth moves) will make the bottom lid crinkle and compress upward.

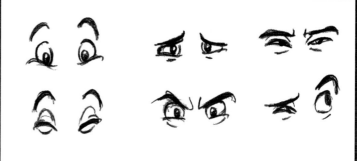

• **PUPILS** are especially expressive. Looking off to the top left or right can indicate deep thought. A downward glance can indicate sadness or confusion.

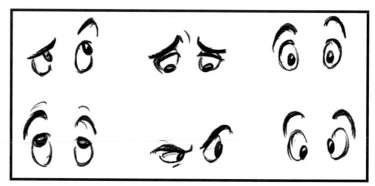

Here's a character looking to the left in the most basic way.

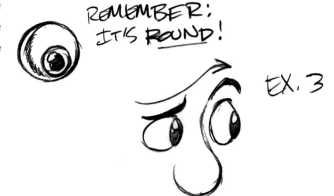

Flattening one side of the pupil will help impart a sense of direction. Using the shape of the eyebrows to compress one side of the eye and stretch the other exaggerates the eye direction even more.

REMEMBER:
IT'S ROUND!

EX. 3

EX. 2

Work with the eyes to create all kinds of different expressions. Here are a few I thought up using different kinds of eyes as examples. Pushing the pupil outside of the eye circle is a cartoony "cheat," but it's also a surefire way to create a stronger sense of eye direction.

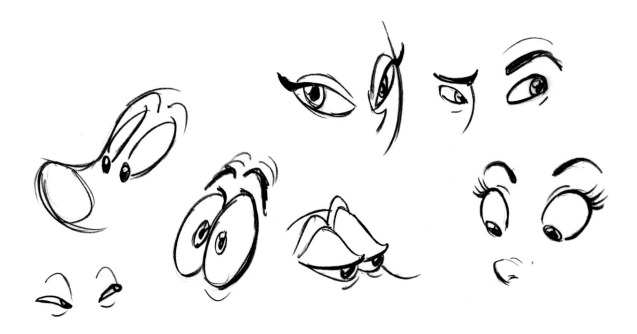

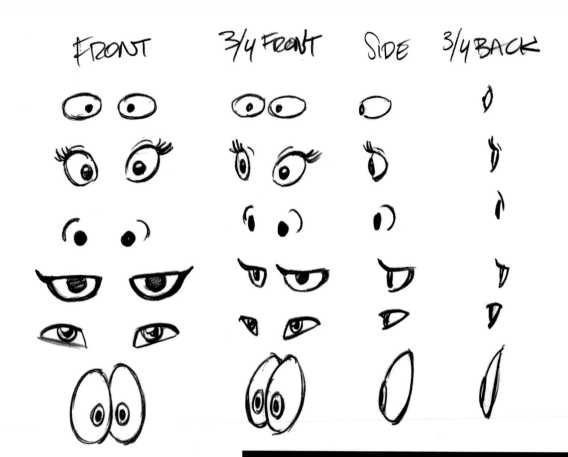

FRONT 3/4 FRONT SIDE 3/4 BACK

WHEN LOOKING DIRECTLY "AT CAMERA"....

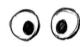

DON'T
PLACE PUPILS PERFECTLY IN THE MIDDLE OF THE EYES.

DO
PLACE PUPILS JUST BELOW CENTER AND SLIGHTLY TOWARD INSIDE OF EYE.

WHEN 3/4 ANGLED EYES LOOK TO THE LEFT...

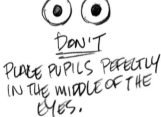

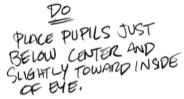

DON'T
PLACE ONE TOUCHING THE TOP OF THE EYE AND THE OTHER AGAINST THE BOTTOM.

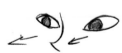

DO
KEEP PUPILS THE SAME—BOTH ARE TOUCHING THE BOTTOM OF THE EYE AND HAVE A SLIGHT AMOUNT OF WHITE AROUND THEM.

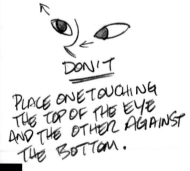

Pupils give the eyes expression. The way you position the pupils will show your characters' thoughts, and also indicate to whom they are speaking and the direction in which they are looking. Here are some common mistakes illustrators make when directing the eyes

It's especially difficult to draw eyes—and almond-shaped eyes in particular—from a three-quarter view. When doing so, you can inadvertently make the character look wall-eyed or cross-eyed. One way to avoid this effect is to make sure the pupils are touching either the top or the bottom of the eye.

GO WITH THE FLOW

Flow is the way all the nerves, bones, and muscles connect together in a naturally rhythmic way in a drawing. When you design characters, you'll create flow with the use of "S" curves.

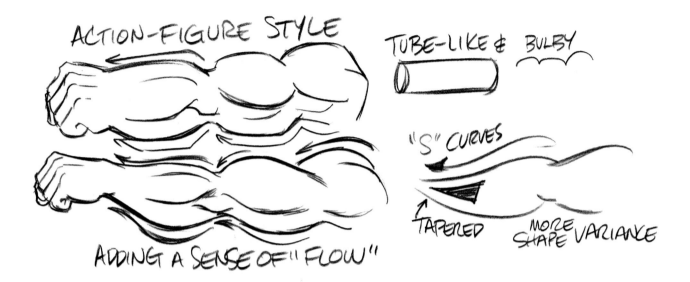

ACTION-FIGURE STYLE

TUBE-LIKE & BULBY

"S" CURVES

TAPERED

MORE SHAPE VARIANCE

ADDING A SENSE OF "FLOW"

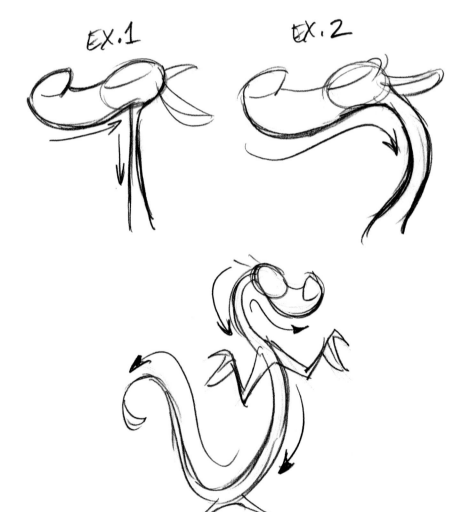

EX. 1

EX. 2

When I was designing Mushu, the dragon in the film *Mulan*, the directors had one major mandate: Make him look different, not like a guy wearing a costume. The design was based on a snake, so there was a certain natural feeling of flow in the drawing (Example 1). But something wasn't quite right. One of the other supervising animators, Ruben Aquino, saw the drawings and suggested having the creature's neck fit into the back of its head rather than the bottom. Bam! That was all that was needed! By moving this connection point, we created more flow from the head all the way through the body (Example 2).

COLOR PERSONALITY

Now it's time to render the characters in our film in color. We will be creating what is described in the animation industry as "color models." On most feature-length animated films, an artist known as the color modelist creates the character color models, working closely with the art director to ensure that the color schemes for the various characters work well with one another, as well as with the background colors in the film. I asked my good friend Paul Conrad, a very talented designer and a genius in the use of color, to act as color modelist for our imaginary film production. Since I had drawn the designs he was coloring, I played the role of director and gave him occasional suggestions as to what colors I saw as I was designing my characters.

The first step was to create tight, inked versions of the characters so they would be clear and easier to color.

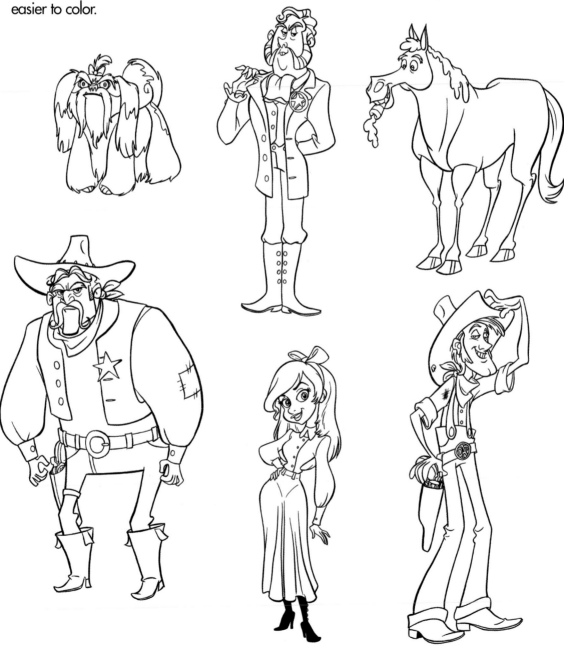

Time to color! Let's start with Dillon. The first thing I did was to go online and look at the work of costume artists who re-create authentic period Western wear. From this research Paul and I learned that cowboys usually wore red bandannas. From the description of Dillon on page 23, we know that our hero has blond hair and wears dirty, ragged clothes. Paul wanted to use a dark color for the hat so that Dillon's lighter hair would stand out, and he was careful to use warm browns. That was in keeping with the general rule of thumb for color models: Good guys wear light, warm colors, and bad guys wear dark, cool colors. The brown of Dillon's pants has a warm, reddish tint that harmonizes with the color of his bandanna.

We liked some of Version 1, but we thought that Dillon was way too dark to look like the good guy. So Paul tried a blue shirt, making sure to push the color to the violet side to warm up the tone a bit in Version 2.

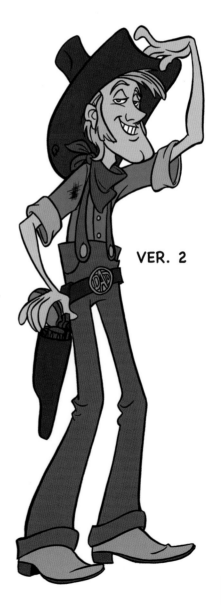

VER. 1 VER. 2

Though we liked the contrast of the blond hair against the dark hat, I felt the hat was just too dark for our hero. Paul tried a lighter, grayish version of the hat and also reversed the colors of the pants and boots to lighten Dillon up some more. Not wanting to have too many light colors, he changed the shirt to a darker warm brown.

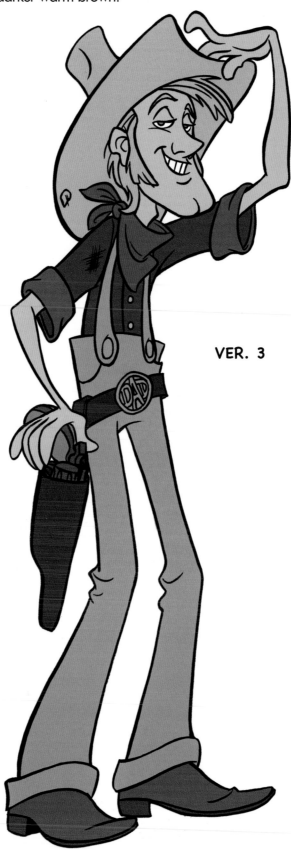

VER. 3

We really liked the light gray hat and the brown leatheresque pants, but we wanted to see more color in the shirt. So Paul tried something new, a greenish color. I like this one: I think we got it!

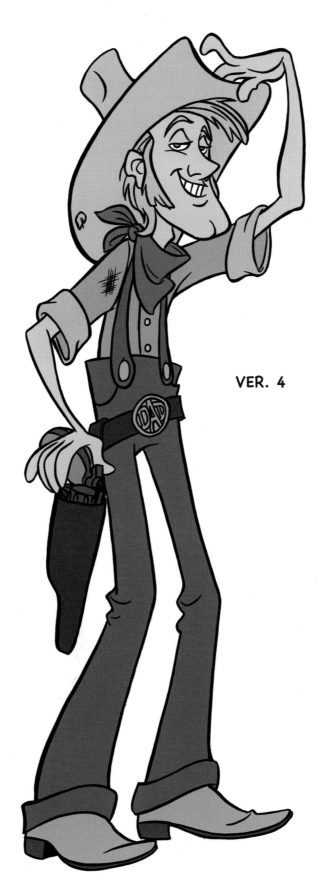

VER. 4

Our research on Western wear in the 1800s showed that brown really was the dominant color of clothing in that era. So Paul started with a very conservative color scheme for Polly. He used Polly's personality, as outlined in the description on page 23, as his guide for making other color choices. He went with a light, natural lip color, as Polly wouldn't want to have garish, bright colors on her lips. The green eyes work well, since green is complementary to red, the color of her hair. We also liked the bright red bow, since it's colorful and speaks to the spunky side of Polly's personality.

Still, our first version had too much brown, and the colors blended together a bit too much. For the next try, we went in a completely different direction. Sometimes you learn what you really want by drawing at the extremes. In this case, we went with bright colors on everything. Even the red on the bow is brighter, more pure. I kind of like the orange hair and the blue of the skirt, but these colors are a bit too extreme.

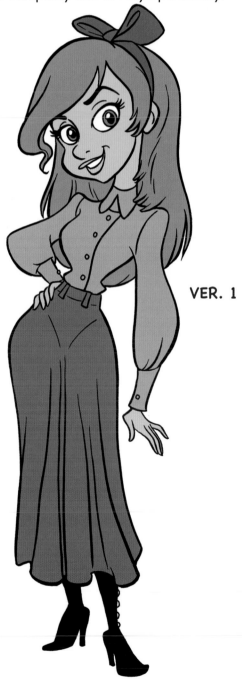

VER. 1

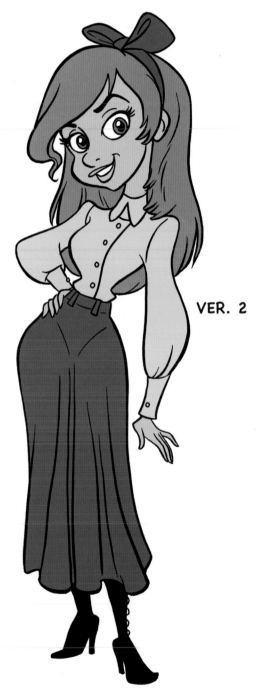

VER. 2

We then went back to some of the more subtle elements in our first version, while incorporating some of the colors we liked from the second version. Paul went with a darker skirt, because it's more conservative and better suits Polly's demure personality. The pink shirt offsets the skirt and reflects Polly's spunkiness. We both liked that. Polly is slightly attracted to both Brent (the villain) and Dillon (the hero), and the tension between these two opposing colors symbolically reflects her ambivalence about the two key men in her life. I really liked the color of the green bow, but felt we were using too many bright colors alongside the pink blouse. It was a tough call....

Ultimately, I just felt the pink was too cartoony and cliché. We went back to the red bow, kept the conservative dark skirt, and used the green that was in the bow for Polly's blouse. This is it!

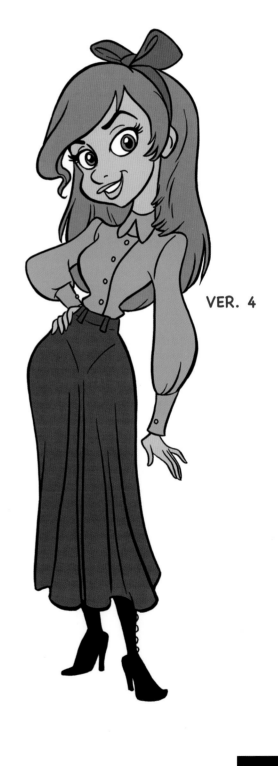

VER. 4

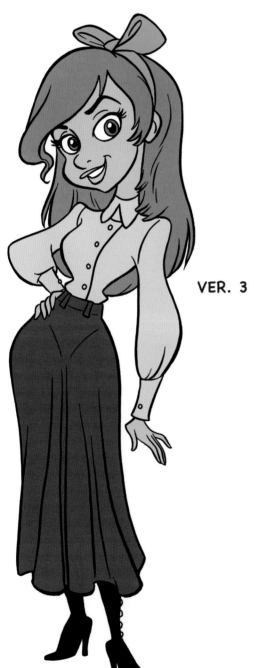

VER. 3

VILLAIN COLORS

Black is evil, white is pure" is an old-fashioned, overdone, and yet (despite all that) tried-and-true expression. Since the earliest days of cowboy movies, the bad guys have worn black hats. So, for Brent, who comes off smooth and suave when he wants to but is greedy and evil to the core, we began with a dark, brown palette.

In the next version, Paul went for a purple coat and darker pants. Purple is traditionally used to show evil. (Through the ages, lots of Disney villains have worn purple.) Still, this color scheme seemed too cartoony for us. We didn't want Brent's evil side to be so obvious that Polly would recognize his true colors (pun intended) right off.

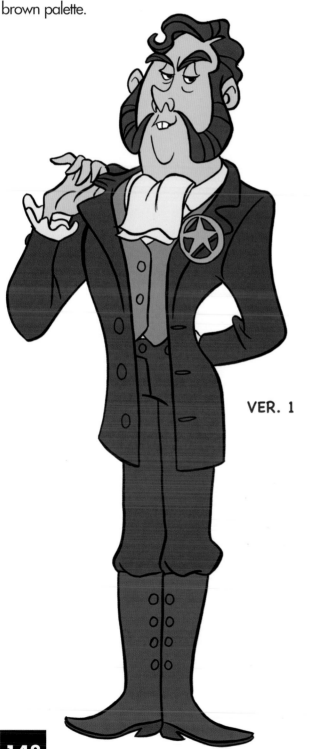

VER. 1

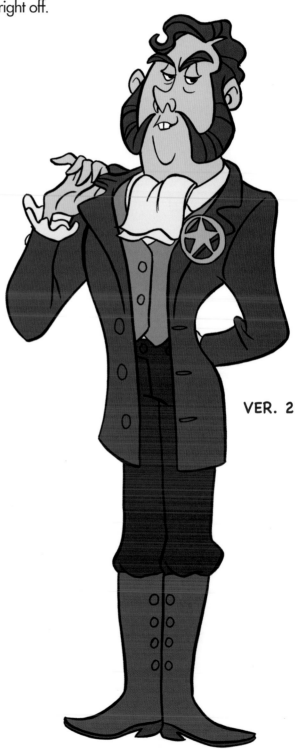

VER. 2

Next we went with a red coat and a vest that's brown, to match the boots. I like this version because Brent is not as cartoony in it as he is in the previous version. Red can convey energy and perkiness (as it does in Polly's bow), but it can also be symbolic of evil. My problem with this version is that these colors make Brent look like one of those aristocratic Brits who ride around on horses blowing into curly horns and hunting foxes.

Time for something totally different! Paul pulled out all the stops and went in the other color direction. In the final version, Brent's boots and jacket are a light, creamy gray, and the jacket has gold buttons that tie in nicely to the sheriff's badge. These colors work well because while they're lighter than the colors in the other versions, they are cool and make Brent appear icy, putting him in contrast to Dillon and Polly. The long coat seems British and Old West at the same time. This final version is not what I expected, but it works beautifully. These colors hint at the evil side Brent will reveal to Polly later in the film.

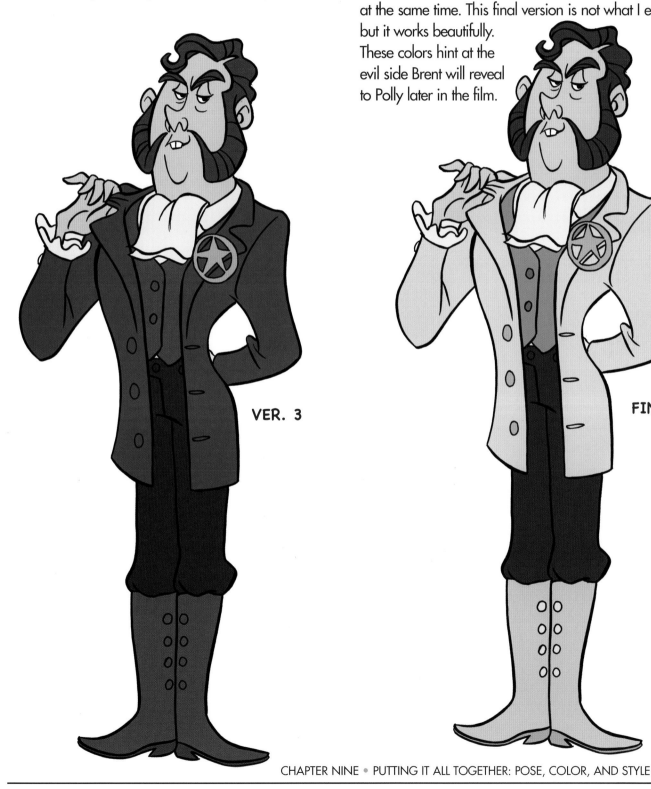

VER. 3

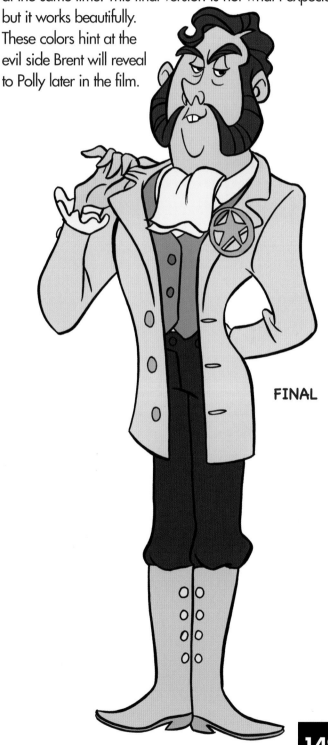

FINAL

ROUNDING OUT THE CAST

Our goal in creating color models for the rest of the cast was to select colors that spoke to the characters as individuals, with a nod to how those characters would look when playing a scene together.

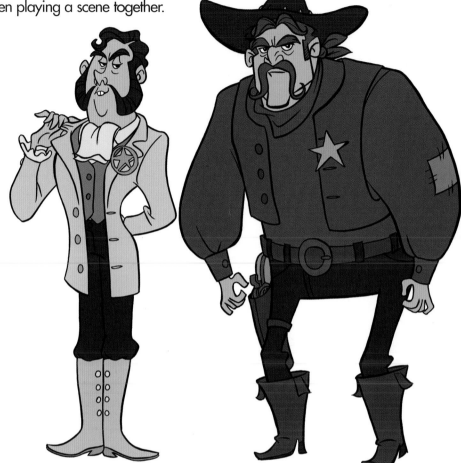

GRIT As the bad deputy to the even worse sheriff, Grit is all meanness. He doesn't have the suave side that Brent does, so his colors can reflect his evil intentions right off the bat. Grit was the one character for whom we wanted to make heavy use of the brown colors we saw so much of in our reference sources. Also, a black (or close to it) hat seemed a natural. These colors also looked good juxtaposed against Brent's color scheme, when the two bad guys were shown together.

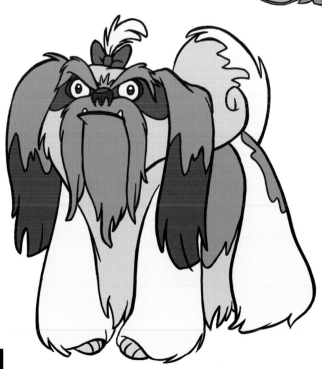

RUTHIE The color scheme for Polly's feisty little pooch who has a crush on Dillon is pretty straightforward: Ruthie looks like the Shiatzu dog she is. This breed does have some color variations, but we went with warm gray spots that work well with Polly's colors. Paul added some nice touches: cool gray eyebrows that stand out, and a red bow to match Polly's.

CARROTS Dillon's horse is addicted to carrots, so his mane and tail are orange. Meanwhile, his ears are a little rabbitlike, another fun element. His true-blue eyes reflect his loyalty to Dillon.

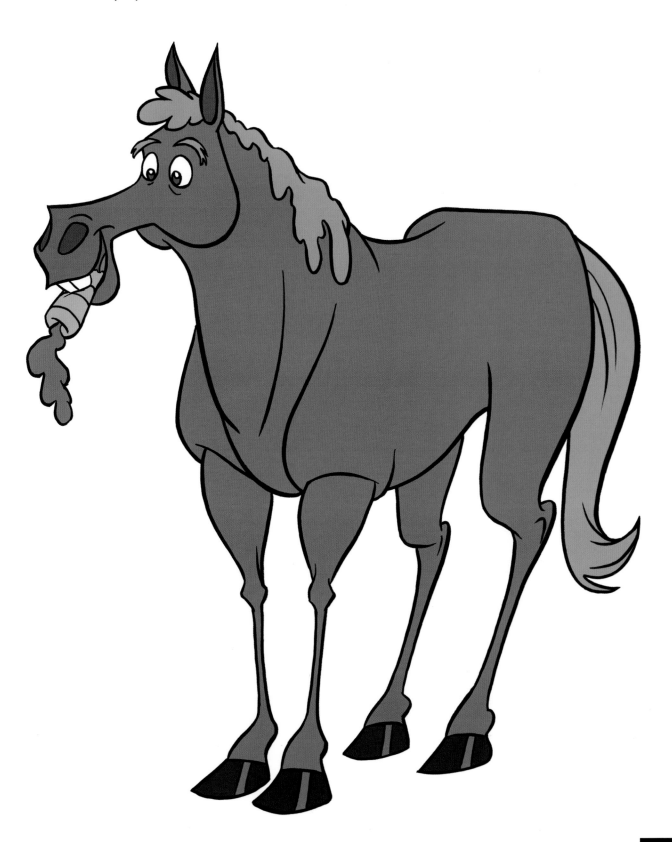

CAST COLOR HARMONY

Color harmony refers to how the various colors of all the characters work together. If we've done our jobs right to this point, then we should be close to having a cast of characters that looks good in a "group portrait." After all, we didn't create each character in a vacuum. All along, we were thinking about how the characters would look together. Would they harmonize?

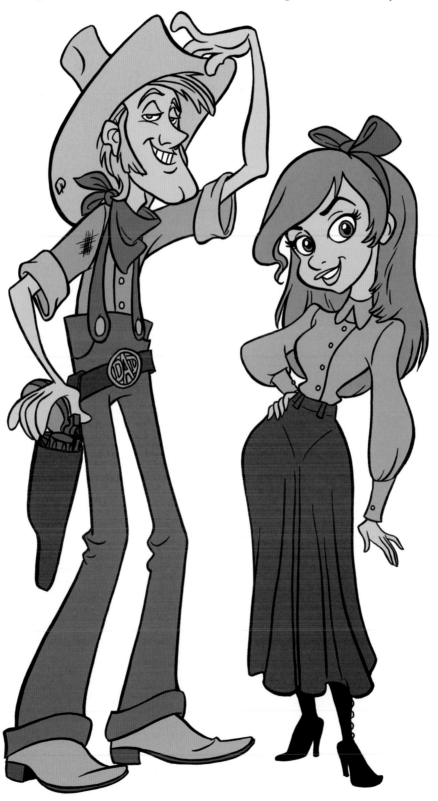

Oops! We missed one element: In our efforts to make Dillon and Polly look good together, we accidentally used the same color for Dillon's shirt and Polly's blouse. They're not brother and sister, so we needed to adjust the color of Dillon's shirt. Here is the final color lineup for our Western film. If I may say so, everyone looks pretty good together.

FINAL CHARACTER LINEUP

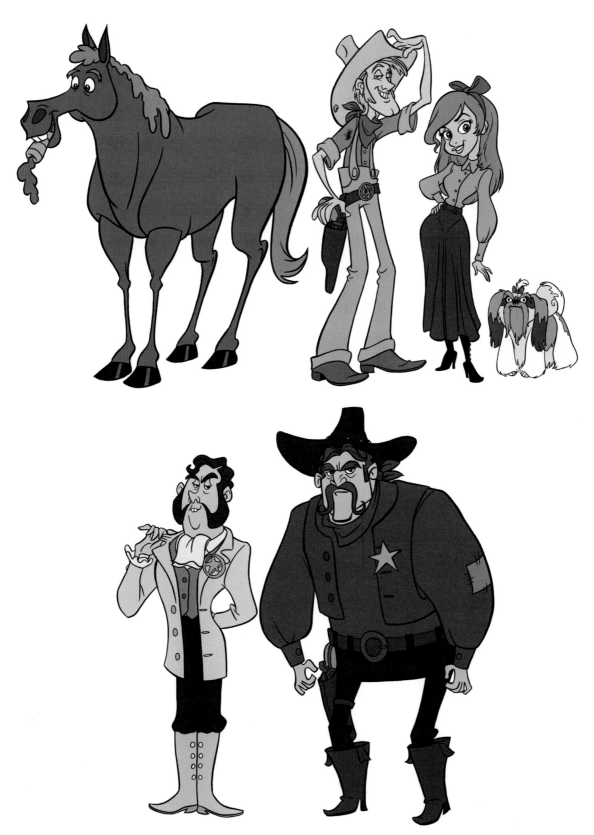

STYLE

Any project has its own style, and style is all about consistency—using certain elements repeatedly in the designs of various characters. Is the style angular or rounded? Is it made up of a little of both? Are the eyes on all your characters really big, and do the characters have tiny mouths and sharp-angled noses? To show some examples of how to apply style, I have illustrated the same character, a generic yet attractive female character, in different styles that would work for different types of roles. Notice just how much style can differ, and how much style affects the way a character comes across

COMIC BOOK

Comic-book characters are usually pretty detailed (that's largely because you don't need to draw them again and again). Superheroes in the comics tend to be based on real anatomy, are very illustrative and realistic, and are usually drawn with a lot of shadows and cross-hatching. For me, drawing a comic-book character is exhausting.

I grouped TV and Web animation together because both are usually considered limited animation, thus many of the same design rules apply to each. Limited animation means that only part of the character's body, such as the mouth and eyes, moves. For this reason, you need to build breaks—places in the design where one shape is cut off from the next—into these kinds of characters. With these breaks in place, an animator can easily place the part that moves (such as the head) onto a part that doesn't move (like the body).

FEATURE ANIMATION

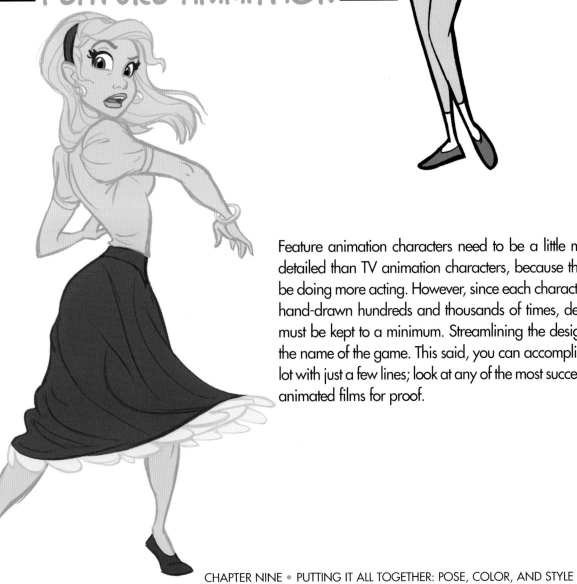

Feature animation characters need to be a little more detailed than TV animation characters, because they'll be doing more acting. However, since each character is hand-drawn hundreds and thousands of times, details must be kept to a minimum. Streamlining the design is the name of the game. This said, you can accomplish a lot with just a few lines; look at any of the most successful animated films for proof.

CG ANIMATION

Computer-animation characters and traditionally drawn animation characters are not that different, but CG (computer graphics) characters can have more textures, shines, and highlights to them. The most attractive CG characters are the simplest ones, with their look enhanced by details such as patterns on clothing.

VIDEO GAMES

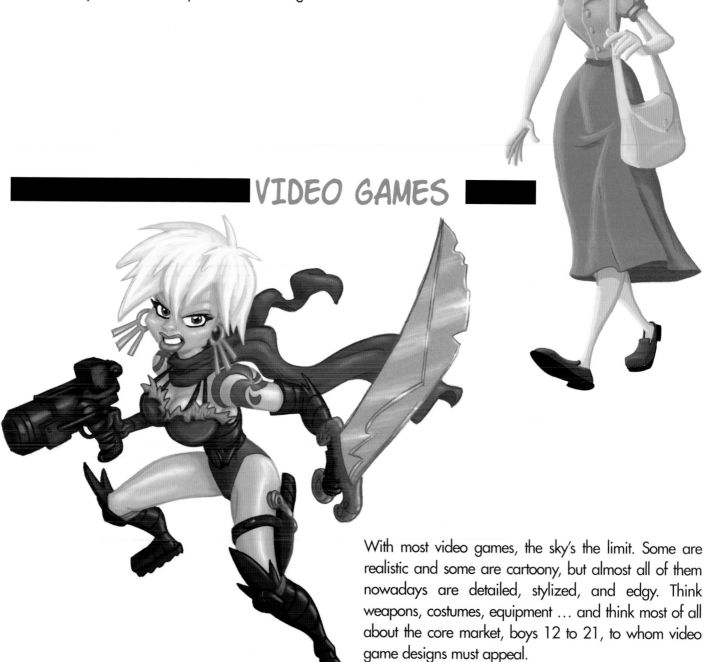

With most video games, the sky's the limit. Some are realistic and some are cartoony, but almost all of them nowadays are detailed, stylized, and edgy. Think weapons, costumes, equipment ... and think most of all about the core market, boys 12 to 21, to whom video game designs must appeal.

There are different styles within the Manga world, but certain elements repeat in most of these characters: big eyes, small mouths, jagged hair, skimpy outfits. Faces are extremely caricatured, bodies less so.

COMIC STRIPS

Comic strips come in many styles, but one element is common to all: simplified characters. This is largely because comics need to be reduced to very small sizes. Also, the creators have to draw these characters over and over again. Comic strip designers get to cheat between front views and side views. Since you never see the character move from the front view to the side view, the two views don't have to connect fluidly, as they do in animation.

As I sit here at my kitchen table writing these final thoughts I can honestly say this has been a great ride. I hope you enjoy this book as much as I did creating it. I am thankful that this book afforded me the chance to work with some of the most talented (and kindest) creators in their given areas of expertise. All of them were exceptionally supportive of the book and the idea behind it. They, like me, have a passion for creating characters and bringing them to life in some form. My wish is that one of you readers—or hey, maybe more than one on you!—will go on to create characters that will live on for years to come.

Thanks for coming along on this trip with me. Good night.

Tom Bancroft

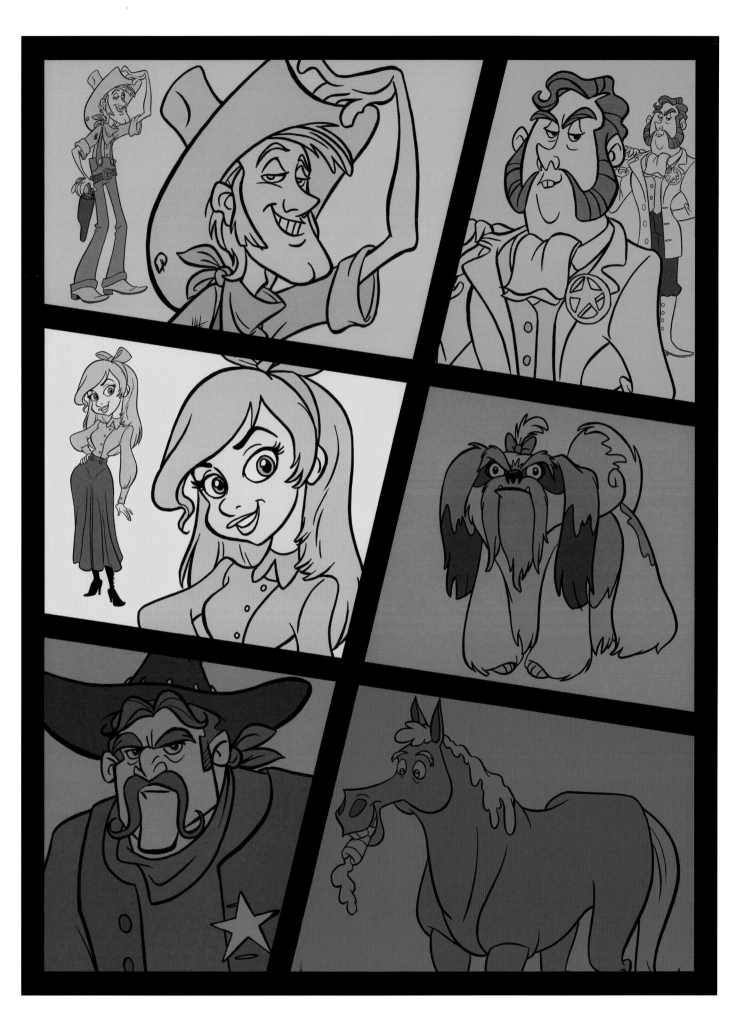